THE AMERICAN ROCKIES
PHOTOGRAPHS BY GUS FOSTER

MAY 16 - AUGUST 22, 1999

THE ALBUQUERQUE MUSEUM

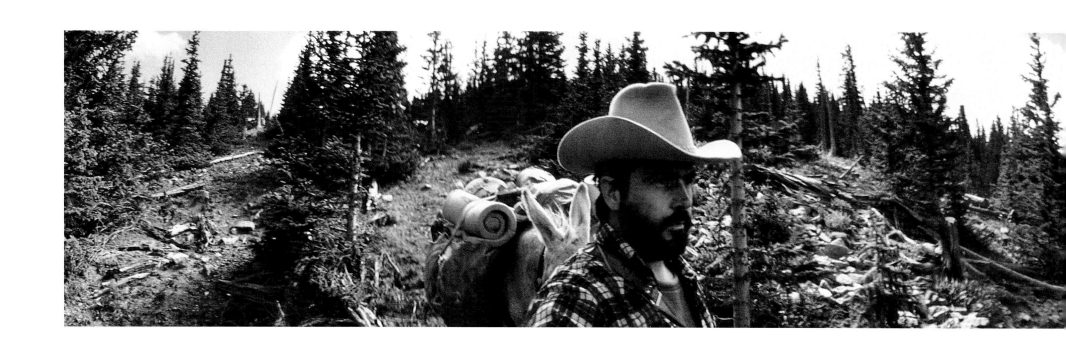

THE AMERICAN ROCKIES
PHOTOGRAPHS BY GUS FOSTER

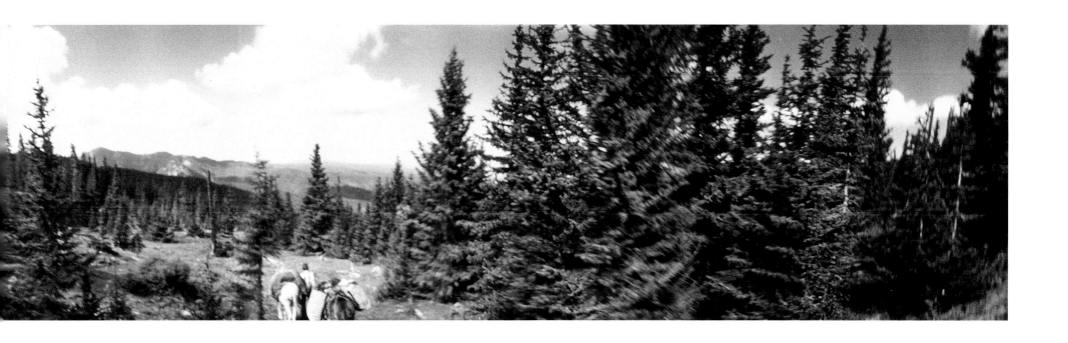

This catalog has been
published in conjunction
with the exhibition,
THE AMERICAN ROCKIES:
PHOTOGRAPHS BY GUS FOSTER,
which is organized by
The Albuquerque Museum.

©1999
THE ALBUQUERQUE MUSEUM
2000 Mountain Road, NW
Albuquerque, New Mexico 87104

Library of Congress
Catalog Number:
98-76201

Cover photograph:
Detail of *Cirque of the Towers*, 1990
Wind River Range, Bridger Wilderness, Wyoming
380 degree panoramic photograph
Title page photograph:
Self Portrait with Stewball, c. 1983,
Pecos Wilderness, New Mexico

ACKNOWLEDGMENTS

The Museum is pleased to present this extraordinary visual diary
of Gus Foster's Rocky Mountain odyssey. Gus has been more than gen-
erous with his time, his tales, his expertise, and most importantly, his
photographs. His vision rivals the grandeur of the landscape itself, draw-
ing the viewer into a space that is vast and powerful. Working on this
project has been an educational, exciting, and rewarding experience for
the entire museum staff. We are grateful for the opportunity to work
with Gus.

Our sincere thanks go also to James Enyeart, Alan Wallach, and
Roger Badash; their contributions to the catalog give the reader a sense
of time and place for Foster's photographs, a context in the history of
panoramic imagery, and a feel for the trauma, travail, and joy of trekking
up and down the mountains.

Ellen Landis, Curator of Art, The Albuquerque Museum

Contents

Introduction
J a m e s M o o r e
D i r e c t o r
T h e A l b u q u e r q u e
M u s e u m

Mountains are mysterious. They are often named for gods and heroes, and like their namesakes, they are turned by our thoughts into metaphors for contrasting emotion: dangerous, sacred, terrifying, inspiring.[1] For centuries, from Moses to Martin Luther King, people have turned, literally and metaphorically, to mountains—seeking solitude, challenge, enlightenment, and wisdom. In mountains we look for something we can find nowhere else. And we accept the strenuous effort required of the journey, knowing that we will be repaid by the exhilaration of a magnificent view. Many roads in the West still attest to the history of mountains as the horizon markers that once guided overland travel; people who live near mountains orient themselves visually by familiar outlines seen against the sky, presences that offer a sense of comfort and belonging. As landscapes where we look both outward and inward, mountains are, fundamentally, about seeing.

Gus Foster's ambitious project to extend our vision along the "backbone of the continent" is at once rewarding and humbling. Time and again his panoramic image places us in a position that is privileged by its commanding view, yet this momentary power is charged with apprehension, for the photograph also suggests, even though we know it is told in fictional terms, that we are alone in this remote place. These are the aesthetics of the sublime, brought forward from the late eighteenth century to our own time.[2] But if wisdom follows fear, the sense of being alone on the mountaintop is often replaced by a deeper understanding of being connected.

Seeing the "body" of the earth from the top of a mountain—a view that no other vantage point allows—enables us to begin to perceive systems in nature: the relationships between ridges, valleys, streams, changes in vegetation, the way in which weather moves across the terrain. These relationships make up the complex of forces that create the watershed, and the boundaries between the parts of the system denote what Gary Snyder has termed the "markers of the natural nations of our planet."[3] As we begin to comprehend the territories held by these "natural nations," our perception transcends conventional political borders. To spread our vision along the continental divide, as Gus has, is to connect intuitively with the larger systems of the living planet.[4] Like the panoramic photograph, the view from the mountaintop can be taken in

quickly; but learning the knowledge held in the "severe, spectacular, spacy, wildly demanding, and ecstatic narrative"[5] of this landscape can take lifetimes. Most people who have lived in the American West over the past half of a century can describe great changes they have observed in their own lifetime, an indication that our transformation of the landscape is moving at a pace faster than we can control. Gus's panoramas are grand vehicles to stir the emotions, but they also present to us an image of complexity and diversity that we will have to understand much better in the next century if we are to survive.

Gus's vision is large. His effort is immense, well beyond what most people are willing to endeavor. Gus is like a modern-day Han-shan, the seventh century Chinese poet of the Cold Mountain Poems, who wrote:

> Men ask the way to Cold Mountain.
> Cold Mountain: there's no through trail.
> In summer, ice doesn't melt
> The rising sun blurs in swirling fog.
> How did I make it?
> My heart's not the same as yours.
> If your heart was like mine
> You'd get it and be right here.[6]

Gus takes us to places most of us will never go. ■

NOTES
1. Marjorie Hope Nicolson, *Mountain Gloom and Mountain Glory: The Development of the Aesthetics of the Infinite* (Ithaca, N.Y.: Cornell University Press, 1959, reprint, Seattle: University of Washington Press, 1997), passim. **2.** Foster's own inspiration for photographing the length of the Rockies came, in part, from viewing a satellite photograph of North America published by National Geographic Magazine, an image that carries the same implications on the grandest possible scale. **3.** Gary Snyder, "Coming into the Watershed," in *A Place in Space: Ethics, Aesthetics, and Watersheds* (Washington, D.C.: Counterpoint Press, 1996), 220. **4.** Standing on the continental divide has mythic qualities in American culture that connect us as a nation from sea to sea, as indicated by the often-repeated statement that a drop of water that falls on this side will end up in the Atlantic Ocean and on the other, in the Pacific. And by extension of this notion, watershed, as a metaphor, is often used as an indicator of an event of major proportions, whether in national history or personal affairs. **5.** Snyder, op. cit., 224. **6.** Gary Snyder, *Riprap and Cold Mountain Poems* (San Francisco: Four Seasons Foundation, 1969, reprint, San Francisco: North Point Press, 1990), 42.

A lifetime of travel places Gus Foster in a succession of artists who have gained insight and inspiration from the exotic and unfamiliar. In the nineteenth century the designation "traveler" was reserved for either the idle rich, explorers, or social anarchists such as gypsies, artists, and entertainers. The shared goals of seeking knowledge, expanding opportunity, learning new skills, satisfying curiosity, and most importantly, digging a deeper well of emotional experiences that would mold, explain, and define their personal selves, bonded this unlikely group of travelers. The invention of photography, in the middle of the century, brought the world to everyone's doorstep, virtually overnight, and also helped stimulate a desire on many people's part to experience foreign lands and cultures first hand. Photography fueled a new industry in the form of tourism. As transportation simultaneously improved, shortening time and lessening the difficulty required to cover great distances, the concept of being a traveler in the original sense began to lose its distinction of privilege or eccentricity. Traveling because it was possible, rather than as a personal obsession, changed the very nature of travel itself.

Today, people travel regularly to their destinations of choice regardless of distance. Travel itself has created a new vocabulary—commuting, tourism, vacations, and visits. "Visiting" a foreign country for some is an experience similar to visiting Disneyland. Travelers rush to acquire impressions of the unusual and the dramatic; these impressions enhance their sense of worldliness and add to their accumulation of new places, events, and sights, the "rewards" of travel. These modern-day travelers might have become travel minded, but are not, for the most part, travelers with an interest in the same philosophical and subjective qualities as the nineteenth-century irrefutable traveler who sought an expanded vision of self.

The exceptions, here at the end of the twentieth century, are artists such as Gus Foster who express the original traveler's commitment to exploring the potential of new places. These artists reveal a deeper sense of self-awareness, and share their insights in the artistic work they produce. As travelers—and the list includes many of the world's image makers—such artists extend the nature of personal experience into the realm of aesthetic experience. The hardship and sacrifice that inevitably accompany the production of works of art, knows no bounds, but creating art satisfies personal obsession and also gives something of value to the public. Ironically, an artist's selfishness of purpose hides a selflessness that binds art to the public.

Gus Foster first manifested this traveler's motive as artist in 1972. While driving around California he photographed through his car window, using his camera as a notebook, a record of where he had been. It was for him, as he recently described to me, "a process which lent itself to self-examination and a means of reconstructing the feelings and experiences of my travels." This experience, photographing through the moving car's window, greatly influenced his later use of panoramic cameras and his exploration of the panoramic technology's inherent philosophic characteristic, time itself.

In 1975 Foster experimented with making films through the moving car's window, films that did not require editing. These films combined

A Traveler's Notebook: Reconstructing Feelings
James L. Enyeart

the still image as a notebook concept with the moving image's ability to add a sense of time. With these experimental films he discovered his love for the comprehensive, complex element of time intrinsic to photography. An element that was made even more apparent by the moving image of 16mm film, and later rediscovered by him in the nature of the panorama photograph. Foster recalls what he felt while making one of his films: "I would drive sixty miles in sixty minutes and make one continuous shot—something in that experience of viewing the world through a car window evoked in me a meditative feeling. One such film was titled *Death Valley Sunrise*. This film began in the hour of predawn blackness, proceeded through twilight over a mountainous ridge on the horizon to the east, to the completion of sunrise—all the while recording the sound of the moving car."

During this time Foster purchased his first panoramic camera, at the suggestion of a friend. He has since then acquired more and more sophisticated equipment, cameras that can produce negatives of continuous exposure as the camera lens rotates 360 degrees or more. Foster believes that his car window experiments led him to an awareness of the potential of the panoramic photograph and also led him to adopt it as his medium of choice.

Foster and many other photographers are quick to discuss and acclaim the merits of their equipment; they acknowledge the rigorous requirements for making images in especially difficult situations, such as Foster's scaling of mountain peaks. But this essay concentrates on the images, rather than on equipment, process, and technology, with the intent of imparting a deeper understanding of the photographs as idea. All too often visual content in photography is obscured by a fascination with its technology. I do not discount the importance of mastering the uncooperative mechanics of panoramic cameras. But once the vision is in place, an artist's choice of materials and technique are but the price of admission for aesthetic discovery. We may admire the craftsmanship behind process, but we are not confronted with it in our role as viewers. What we see in the final work requires more than admiration. Works of art demand of viewers understanding, empathy, and a willingness to be emotionally and intellectually guided by the artist's ability to reconstruct feelings.

A 1991 project of Foster's revealed the depth of his traveler's approach to making photographs, and disclosed the sophistication he brought to making panoramic images. Inspired by the early-nineteenth-century wood-block prints of the Tokaido Road by Ando Hiroshige, Foster retraced the route of the fifty-three stations, described by the artist, that dotted the landscape between Tokyo and Kyoto from the eighth century on. He saw in Hiroshige another traveler who memorialized fleeting emotional responses to the beauty of a linear, panoramic landscape (the 300-mile length of the Tokaido Road), and who also used travel to reveal the elements of his aesthetic desire. In a 1993 artist's statement Foster wrote of the parallels between his scroll-like photographs and the westernized realism in Hiroshige prints: "People are as fascinated by kite flying today as they were then, the rain that fell on paper parasols then, falls on today's umbrellas, people that gathered at

the shrines for festivals then, attend the same rites today. Now the memento is a group photograph at the Temple gates. The monumental work made by an artist 160 years ago still speaks today; it was his effort and the panoramic account of life in his time that led to my own journey and an account by a traveler in the late twentieth century."

Foster left Los Angeles in 1975 to move to Taos, New Mexico, where he and the artist Larry Bell bought a studio together. When Foster reflects on the artists he admires, like Hiroshige, who have had some ambient effect on his visual thinking, he includes Larry Bell, Robert Rauschenberg, and Edward Ruscha for their command of their materials and ideas. He also includes photographers Lee Friedlander, Garry Winogrand, Jacques-Henri Lartigue, and Henri Cartier-Bresson, who for him represent time, time as life itself, where the appearance of reality is defined by photography.

In Taos Foster narrowed his interests to the panoramic photograph and began exploring its inherent potential for rendering elements of time, leaving tracings of circumstances in which time past and time present were simultaneously represented at the beginning and the end of an image. Shadows of people and objects revealed the passage of time in an otherwise still and contemplative tableau. He liked the elements of the panoramic process that paralleled his earlier films. A ten-inch-wide roll of film, six feet long, made a negative of a 360 degree panorama, which was comparable to filming a continuous image for sixty minutes at sixty miles per hour. Foster saw and felt a 360 degree turn of time. In the space of its rotation, events and positions of objects had changed

and time had its own way with the world and with the making of an image.

In his photographs, Foster's interest in the unpredictable evidence of time's many faces is held in a kind of aesthetic suspension. He combines the variable that he cannot control, time, with his highly visual instinct for pleasurable images. His personal feelings, his reactions to the reality of the moment, imbue the subject matter of his photographs. For the viewer Foster's photographs are silent testaments to the commingling of the eternal nature of time and the very temporal nature of our observation over which it has dominion. Foster reconstructs feelings that merge from the intellect and the emotions simultaneously in stasis. The result is the Zen-like beauty of Foster's panoramas, a beauty that engulfs viewers without explanation, in ways different from most other panoramic images by photographers who focus only on the uniqueness of the technology.

Once in New Mexico, Foster turned into an outdoor person with yet another obsession to embrace, hiking in wilderness country. As he explains it, he became totally immersed in the outdoors not because it was *there*, but because it was *everywhere*. He was already a student of the work of photographers who preceded him in the artistic pleasures of the majestic and primordial Southwest landscape, William Henry Jackson and Timothy Henry O'Sullivan among them. He felt the lure of the mountains, just as they had, because hidden among the snow-capped peaks were visions and vistas not yet seen by the human eye.

Between 1978 and 1981 Foster's approach to selecting and pho-

Bradford Washburn, Mt. Huntington, Alaska.
October 3, 1964. Photograph courtesy
Panopticon, Inc., Boston, MA

tographing various mountain peaks in the Pecos from both their bases and summits reflected no particular pattern. He made his choices randomly according to where he thought he would like to test himself and his equipment, where the reward might be especially pleasing. Then in 1982 a friend invited him to join him in a hike to the summit of Handies Peak in the San Juan Mountains of Colorado. This 14,000 foot peak turned out to be an oracle of sorts for him. It was, as he told me, "like looking at infinity from all points on the compass—all the world became a single emotion." In these words Foster veritably describes his panoramic photographs of the Rocky Mountain Range from Canada to Mexico. After Handies Peak, Foster returned to the Pecos Wilderness in New Mexico where he became addicted to "the image," that is, making panoramas that could recreate his epiphanous experience at Handies Peak. A pattern to his choices of images began to emerge as he obsessively set out to climb most of the peaks of the Pecos Wilderness. So, while in his early forties, Foster finally found in nature an experience that exactly matched his intuition for what the panoramic image should contain. For him, the mountain peaks became a single emotion and the elements of time and observation became a single image.

The extraordinary nineteenth-century photographers Vittorio Sella, Samuel Bourne, and the Bisson Frères, set the standard for making large format photographs in the mountains of Europe and India; but it is not their legacy that can be called upon when trying to find comparable images to Foster's, or a comparable passion for photographing at the summit. Certainly, the difficulty quotient is present in these nineteenth-century pioneers' works considering they prepared and made large glass plate negatives in the field. And their keen eyes and aesthetic choices are faultless. But their drummers are too distant and the look of their images too restrained. It is, rather, from the work of a twentieth-century photographer, scientist, mountaineer, artist, and traveler that an artistic endeavor relative to the Rocky Mountain images of Foster is found.

Bradford Washburn, who by age twenty-seven in 1937 was the preeminent mountaineer and photographer of the Alaska Range, also became this country's leading aerial photographer of Mt. Everest in the Himalayas and Alaska's Mt. McKinley. His aerial photographs of mountain ranges from the Alps to New Hampshire's Presidential Range remain the very maps used by climbers to make ascents and plan climbing routes the world over. Washburn, now eighty-eight years old, continued actively photographing and mapping the world's highest peaks well into his seventies. His achievements are legend in the scientific world. His photographs, however, were about more than the exacting science and perfectionism required to produce large format images from the air.

The Museum of Modern Art, the George Eastman House, and the Center for Creative Photography, among many other museums, have included his photographs in their collections and exhibitions for decades. His work, a forerunner to Foster's, is about the joy and love of high places and about sharing the drama of those singular moments where time is suspended. He, like Foster, has been a traveler in the original sense for over half a century, letting no mountain peak of respectable challenge escape his eye or his passion for creating a

work of art that does justice to the experience of having been there.

Washburn's and Foster's lives share similarities other than their commitment to photographing mountain ranges. Washburn chose to refine large format aerial photography while Foster chose the grand panoramic format. Both photographers pushed their tools beyond the expected range of possibility. Both photographers' backgrounds include museum experience. Washburn was Director of the Boston Museum of Science for most of his career (and holds the title of Honorary Director to this day), and Foster was Curator of Prints and Drawings at the Minneapolis Institute of Arts early in his. Their scholarly and educational experiences deepened their understanding of the merits of research and planning in the execution of their photography, helping to lessen the advent of failure and the potential of a fatal accident.

The value of identifying Washburn's work as a significant prototype to Foster's imagery lies in the fact that every good idea needs to be continuously reinvented or it dies. It matters little that these two photographers do not know the work of the other. It matters greatly that the world knows that they exist and have taken very different but related paths to unimaginable parts of the world.

Foster refers to himself today as the adopted son of the Rockies and admits that the Rockies are all he needs the rest of his life. At age fifty-eight he will not be climbing Mt. McKinley, but the Rocky Mountain Range remains in reach and has become his metaphor for the panoramic image. Foster describes the Continental Divide as the place where he walks along the spine of the United States. Now he has con-structed a pattern from this metaphor by observing that at the top of any given peak in the United States Rockies he can see for about one hundred miles. So each new peak he photographs is approximately one hundred miles away. Although such a pattern might seem arbitrary, the photographed peaks can be connected by dots on a map, revealing their own pattern in the making.

With Foster's newest panoramic metaphor and its earlier manifestation on the Tokaido Road, time is once again the leading issue. The geological time that created and placed the Rocky Mountain Peaks in their configuration is for Foster becoming real time, stretching into its own measure, forcing a longer view of the elements of time in our lives. Here in this exhibition is the broadest possible view, a true panoramic vision, of what it is like to see time turn back upon itself. ■■■

James Enyeart is the Anne and John Marion Professor of Photographic Arts and the Director of the Marion Center at the College of Santa Fe.

A Spin in the Wilderness
Roger Badash

"**D**amn! You boys need a new trailer." The welder stood in the doorway of his shop and gave us the bad news. High and dry on a hot noonday in Belgrade, Montana, with broken steel and a sagging axle. Three guys a thousand miles from home with a few hundred pounds of gear and two burros—a little much to hitchhike with down the Interstate. Then the circles started overlapping.

Gus Foster, panoramic photographer, originally hails from Wisconsin. Well, it turns out, so does the husky owner of B&W Welding and his husky son. And what town are you from? "Wausau," came two simultaneous answers, from Gus and the welder. We were all smiling now. When it turned out that both men were married in the chapel of St. Mary's Hospital in Wausau *and* have the same favorite sausage shop on Sixth Street, we were in solid. The floor jacks rolled out, the welding rods began sparking, and while the burros nibbled the parking lot weeds, the Foster Project got patched up and on the road, saving both the trailer and the season's trip.

Such welcome seems to be the rule, not the exception, when it comes to Gus Foster's twenty-year odyssey with camera, roaming the high ground of America. The quest for the peaks and promontories of the Continental Divide winds through many valleys, across borders, beside rivers. It rolls down highways and up trails, but is always carried along by the people of the mountains, capturing imaginations and opening doors (and gates) throughout the West. Still friendly after all these years.

Our paths first crossed when Gus Foster came calling in 1979 in search of some pieces of the handmade furniture I was making back then. My country road was at its temporary impassable stage in the soggy end of March, and his vehicle was stuck to the axles in mud a mile from the house, with the sun going down. No assistance available until daylight.

With no other possibilities open to him, Gus became our guest, compelled to stay for dinner and the night. By morning my family and I had learned that he had a unique, but cumbersome, antique box camera that could shoot a 360 degree image from the top of my nearest and favorite mountain, the 12,800 foot Jicarita Peak in the Pecos Wilderness of northern New Mexico. Conveniently, I had revealed in turn that I owned a trio of energetic, but independent-minded pack burros that could facilitate getting said camera onto said peak. (Warning: moving large loads via burro over primitive trails may result in loss of some skin and all patience, according to the Surgeon General.) I became Gus Foster's climbing companion.

It's rare to see a person above the tree line in the Rockies carrying a suitcase. But such was the image Gus and his first panoramic camera, in its pre-Titanic walnut-and-brass case, presented as he lugged it across a boulder field beyond burro range toward the top of Jicarita. The hiking party, which included me, huddled in a depression behind a cairn while he leveled the tripod and wound the spring of the 1902 drive mechanism. Then, with people frozen in place for the next sixty seconds, the

camera slowly revolved in a circle, the spring-loaded gear drive making a clickity ratcheting noise as the negative drank in all the domains of the Four Winds.

Neither of us realized at the time that watching a camera spin, high up in the mountains somewhere across ten Western states, would become the prime focus of Gus's life for the next twenty years. After our first climb together he spent the next several climbing seasons exploring the Rio Grande gorge and the peaks and mesas of the Sangre de Cristos, while also exploring panoramic photographic technique with the stately black-and-white format of the old Cirkut camera.

In the early 1980s, the newest panoramic technology was a Globuscope, a small 35mm hand-held camera encased in sleek aluminum, raised overhead and spun in a few seconds. Gus started making day trips and peak dashes, as well as extended forays, with the trailblazing panoramic camera that was padded and compact enough to fit neatly into a soft purple Crown Royal bag. (Purely medicinal, of course).

While exceedingly light, simple, and color capable, the Globuscope and its 35mm design was still somewhat restrictive for the size of photographic print Gus envisioned developing from his exposed film. Capturing powerfully large images, with some approximation of the humbling scale of the environment, in true color and on modern film, called for a Big Gun from the late, not early, twentieth century. The black-and-white Cirkut would not do, neither would the small format Globuscope.

Gus returned home to Taos from a trip to New York bringing just such a tool, a Globus-Holway Panoramic Scanning Camera, a large-format, highly-engineered device capable of producing wall-size prints of crystal clarity. Sometimes.

Pros: big negative gives great detail, camera fits into one (large) backpack load, spins smoothly with battery/motor drive plate (no chattering gear), can be occasionally repaired in the field.

Cons: never intended for back country travel, the loaded backpack is REALLY HEAVY, sometimes does not spin smoothly or even spin at all, *needs* occasionally to be repaired in the field.

Summary #1: the Globus-Holway Panoramic Scanning Camera can take huge and stunning photographs encompassing tremendous vistas in remote settings.

Summary #2: the occasional fickleness of this camera when placed in the unpredictable mountain setting can result in ruined (or no) photographs. (Warning: situations resulting in Summary #2 may produce monstrous oaths and the thrashing of nearby inanimate objects by the photographer.)

The exciting news now is Gus's newest camera, a computerized small wonder custom-made by a Taos inventor that promises more flexibility and toughness in the wilderness.

Summer, 1986. Gus, my ten-year-old son Joseph, and I were trying to get the Globus-Holway and our camp gear up the Santa Barbara Divide

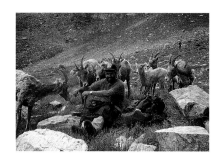

Big Horn Sheep, 1989
Pecos Wilderness, New Mexico
Photo by Roger Badash

and on to Truchas Peak, elevation 13,102 feet, in the Pecos Wilderness. Our temperaments and our endurance were wearing a little thin following an afternoon of walking in the rain. The morning had included lost trails and bog-stuck burros, with a quick chilling squall and marginal hypothermia (my own) thrown in to the day's pot of exasperations. As darkness came on and we consulted the map, we knew we were close to 12,000 feet elevation, in the fog, and somewhere on planet Earth.

Deep booms of thunder blowing in drove us to an instant camp on the least-tilted piece of mountainside we could find in the gloom. We staked down the tent in the whipping rain, dove inside and tried to get warm in our sleeping bags; we dozed, thankful to be out of the elements. Suddenly the world turned pure white as deafening crashes exploded through the treetops above us. Joseph sat bolt upright, shouting "Dad!" as the intense light filled the tent with macabre detail, then disappeared, strobing over and over with each simultaneous thunderclap. Throughout the night we huddled and shrank into ourselves, unable to ignore the rolling waves of sound that shuddered the ground we lay on.

In the soggy but clear morning, a bank of fresh snow pushed against the uphill wall of the tent while water streamed and streamed down the mountain under a pale sky. We regained the trail above and reached the lakes before noon, but the rock above was wet and shiny with new snow and ongoing runoff, discouraging any attempt to get the camera on the summit. Gus set up his gear for a lakeshore panorama, but moments before the camera spun, Joseph called "Wait!"

A basketball-size piece of bubble wrap floated about thirty feet out on the lake's surface; it had blown unnoticed from the camera pack and stuck out like a beacon in the dark water. The combination of trees, lake, peaks, and a big wad of shiny plastic somehow didn't seem to fit right in a Foster wilderness picture. We helplessly watched the wrapping bob merrily away as new clouds began sailing in over the peaks, narrowing the time in which it was possible to capture the scene with acceptable photographic light.

The wind picked up and suddenly began working for us, as the increasing ripples on the lake carried the plastic toward a rock outcropping on the opposite shore. Joseph and I ran around the lake and, by lying flat on a partially-submerged boulder and extending a branch, were able to make a snag. Holding the dripping prize, we concealed ourselves behind the rocks as Gus raced the incoming weather to get the shot. With jackets on and collars up, we repacked the camera, loaded the burros and beat it out of the lake basin and back over the divide, heading down the twelve miles of trail that would return us to the road. Hours later, a certain ten-year-old fell asleep into his dinner plate. All in a day's work when your boss is a camera.

Another range, another year, another dash to beat the thunder. Only this one required patience, as we shared the summit of Kings Peak in northern Utah, 1995, with a lively Boy Scout troop excited at being on the highest point in the state at 13,528 feet. Some days privacy, some

days people. Gus set up the full apparatus, but diplomatically appeared unconcerned while waiting for the gang to descend and leave an uncluttered peak for the photo.

However, the mountains must be shared to be seen, seen to be appreciated, and appreciated to be preserved. With this spirit in mind, the Photographer smilingly explained his equipment and the panoramic process to the boys and their troop leaders while the wind whistled through the fractured slabs of sandstone at our feet. His friend and frequent climbing partner, Santa Fe educator John Chamberlain, assisted as the scouts peered through the lens with Gus. They lined up landmarks in the distance with help from John and his maps, and finally left the mountaintop seeing and knowing more than when they arrived. A little bit of "passing the torch" had taken place. If, in the future, wilderness has a chance for preservation, the young people we encounter in the mountains today will likely be the conservators of tomorrow.

From Utah, in 1995, the camera traveled north along the imposing Wind River Range in Wyoming, toward Pinedale and a trailhead into Indian Basin and the Continental Divide. This was an in-between day, for cleaning up, drying out, resupplying, and a restaurant, in that order. As we opened a second bottle at dinner, a gracious woman approached the table and asked where in New Mexico we were from, as she'd overheard our probably wine-enhanced loud conversation about home. We were soon introducing ourselves to former New Mexicans Professor and Mrs. Luna Leopold, whose family name is written large up and down the Rockies in this century.

Since Gus knew he'd be shooting the Divide in the Aldo Leopold Wilderness Area of New Mexico in the near future, meeting Aldo Leopold's son Luna was an unexpected treat, verging on a sacred honor. Aldo, an ardent conservationist, was instrumental in creating America's National Forest system in the 1920s, and the remote and rugged wilderness in New Mexico's Black Range in the Gila Forest was named after him. Luna is a retired geologist/hydrologist who taught at the University of California at Berkeley and worked with the United States Geologic Survey in many Western mountain ranges. He keeps a summer home in Pinedale near "his" Winds.

Although his own packing days are behind him, the Professor had a trove of information and answers for our eager questions about the terrain we'd be covering in the next days in the Winds, as well as an interest in exchanging news about our homes far to the south. Feeling sustained from the meal and enthused from making a link through the Leopolds to an earlier era in the Rockies, Gus and company hit the trail early next morning in the direction of Indian Lake and Gus's chosen destination: Jackson Peak, named for the pioneering photographer of the 1870s, William Henry Jackson.

At the end of a second day of hiking the trail forked and required a commitment to either Jackson Peak or Fremont Peak. The burros made the call by balking at the fourth stream crossing of the afternoon, despite

John Chamberlain and Sid at Rock Creek, 1995, Absaroka-Beartooth Wilderness, Montana. Photo by Gus Foster

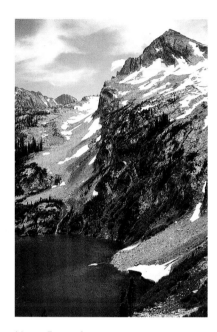

North End of Sawtooth Lake, 1996
Sawtooth Wilderness,
Photo by Roger Badash

all yankings, heavings, and switchings; they forced the party to take the Fremont campsite. From a high vantage point the next day, we realized that had the burros crossed that fourth stream, the Jackson route would have been impassable later on due to deep snow, which was unobservable from below. Animal trail intuition or downright plain feistiness? In the mountains or in Las Vegas, there are no odds given for predicting the mind of the burro. Just tie it on and let 'em roll.

What Luna Leopold had not prepared us for was the ferocity of the hail storm that pounded the high country before sunset. The animals had no alternative other than to turn their rumps into the gale and take a licking. We humans rode out the tempest under our protective skin of nylon and watched the tent floor ripple and burble up beneath us as more water than the mountain could handle ran off the Winds' western slope in a rush to join the Green River miles to the west.

The rewards came the next day when the camera spun atop 13,756-foot Fremont Peak, overlooking the glacier to the east, Jackson Peak to the south, and Wyoming's highest, Gannett Peak, to the north. We shared the summit with climbers from California, Colorado, and Ohio, who obligingly hid from sight during the camera's revolutions. We were especially pleased to find that one of the Californians was further along in his fifties than anyone in our group. There was still hope!

After subsequent correspondence, Luna Leopold encouraged Gus's already formative plan to visit another Wyoming rock fortress two years later, Cloud Peak in the Bighorn Mountains. The Prof had seen an unusually big "protalus rampart" in the 1950s and hoped we could get a picture of it. The rampart, located in a bowl somewhere on the trackless northeast slopes of Cloud Peak, is apparently a 100-foot-tall pile of stones left over from the end of the last Ice Age and something that may require a geology degree to love.

Not only did the location of the rampart elude Gus and camera, the summit of Cloud Peak proved elusive as well. The approach, five miles of jumbled boulders, was well-described in the guidebook, but reading about it and walking on it were two very different propositions. This was one of the first real outings for William, Gus's newly acquired Alpine-La Mancha pack goat, who was along to carry the camera in places where burros fear to tread. About halfway through the boulder field, William decided that he too feared to tread, which required him to be staked out to wait while the humans humped the camera upward.

A good hour spent cowering under a skimpy rock slab, as waves of thunder and yet more Wyoming hail blew through, made time run out. From a bare ridge of dark rock 800 feet below the top, Gus got a photo *of* the summit instead of a photo *from* the summit. In the falling temperature we scrambled downward across alternating sections of snowfield and boulders to pick up William from Goat Parking and get to camp. I guess some of us were a little slow to grasp why a mountain might be named Cloud Peak. Maybe next time, Professor.

Walking out of the Bighorns, we encountered numerous fishermen-and-women trying the lakes along the trail, typical of the thousands who visit the wilderness. I was reminded that Gus and camera have met anglers along some of the West's prettiest waters. Although Oregon's beautiful Wallowa Lake was crowded with fishing lines during the nearby town's Old Chief Joseph Days in August, its smaller cousin Ice Lake, 2,000 feet higher in the Eagle Cap Wilderness, lay quiet for those like us who made the effort to get there.

At Wyoming's Glendoe Reservoir, far from any ocean, sunset fishermen competed with skimming gulls and pelicans on the big water, which is fed by the North Platte River coming out of both the Mt. Zirkel Wilderness and Rocky Mountain National Park in northern Colorado. A visiting rockhound from Casper showed us to a little beach made of thousands of shards of petrified wood. We ended the day with a cool swim under the sky's last pink rays.

Gus has met the fishing hopeful at Sawtooth Lake, nestled beneath the rugged peaks in Idaho, and at Green Lake in Wyoming at the northern end of the Winds, source of the mighty Green River. The camera has traveled past others who were hitting the pools from the safety of the bank in white water streams like Montana's Rock Creek in the Absarokas and the Gallatin River in the Madison Range, or wading into the classic, broad fly-fishing waters of the Big Hole and Bitterroot Rivers to the west.

Bighorn sheep and distant grazing elk have been caught in the camera's eye, as have numerous marmots and picas in their rocky homes above the tree line. Deer have wandered through camp at twilight, while industrious squirrels and chipmunks have found their way into the stacked-and-tarped supply pile to invade the granola stash, nibble tortillas, or gnaw sweat-stained saddle leather for salt. Mountain goats have run from our approaching footsteps in the Pioneer Range in Montana and a moose and her calf have eyed us warily from a bog in the High Uintas in Utah. And so far, although we have known we were sharing the neighborhood, Brother Bear has yet to pay us a visit. (But it's OK, Brother, really—we know you're a busy guy.)

The wild creatures aren't the only ones looking for a meal at the end of their wilderness day. Anyone traveling with Gus discovers that dinner is always worth waiting for. A truly inventive chef, Gus combines local specialties and any other good-looking ingredients spotted in markets (or on trails) to make a meal that would be impressive at home but is transcendent in the field.

We sat one summer evening on a high bank above the Payette River in Idaho's Sawtooth Range watching kayakers slide past. Gus steamed fresh Pacific mussels on the camp stove, laid out salad greens and hard baguettes, and filled the Sierra cups with wine. Not bad for the woods…The feast was followed by the ultimate dessert: two cookies and a dry sleeping bag. This guy knows what we want!

Fresh Boletus mushrooms, 1997
Big Horn Mountains, Wyoming
Photo by Roger Badash

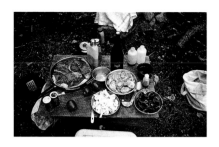

Camp Kitchen—Steak and Wild
Mushrooms, New Mexico 1998.
Photo by Gus Foster

Jicarita Peak, 1979
Sangre de Cristo Range
Pecos Wilderness, New Mexico
360 degree panoramic photograph
Photo by Gus Foster

In New Mexico, on a blustery October evening at 11,500 feet in the Pecos, Gus strengthened the camp with his super-thick beef, sausage, and potato stew, which he'd pre-frozen into quart cubes and packed in the wooden burro panniers. The bubbling stew was served with campfire-toasted tortillas and sliced fruit. He finished us off with cocoa-and-rum all around, JUST what the doctor ordered. It's another winner! I pledge allegiance to the flag of my sleeping bag.

Gus has presented London Broil on the grill and fresh corn in the husks from the coals. We've seen asparagus in butter, tart cucumber salads, and a mean heat-generating curried rice, all prepared in a slightly-dented minimalist trio consisting of one deep pot and two skillets. And, surprisingly often, there is a welcome addition of fresh-picked produce du jour that Gus has gathered along the way: mushrooms such as boletus and chanterelles, wild onions, various berries, all served in, on, or next to that night's specialty.

Indeed, the Gus Dinner is now viewed as one of the prime motivational factors for the support team in getting the camera onto the mountain. So better keep stirring and simmering, Gus. Lose your Michelin outdoor rating and who knows? It could get mighty lonesome in that wilderness!

For the last twenty years, at least, the Photographer has been well-fixed for mountain company. Gus has traveled with a small circle of mountaineers from New Mexico and Colorado, and a large Swedish climber who helped get the camera onto Riggs Glacier for a week in Alaska. He's trekked with his sister, his nephews, some old friends, and lately, some of the children of his old friends, whose twenty-something energy for firewood gathering and burro wrangling makes them HIGHLY DESIRABLE potential camp mates, especially when weighed against their aching-back, trail-weary parents. Hey, it's a forest out there.

As the panorama unfolds into its third decade, the circles keep widening and overlapping, blurring obstacles like borders and bureaucracies and strengthening the chain of those who take nourishment from the wilderness in nature. For Gus Foster, it's a few more revolutions of the tires, a few more strides up trails of dust and mud, a few more nights under the stars as the next century rolls in. So let earth keep turning, mountains keep rising, and camera keep spinning. And keep it wild! ▬

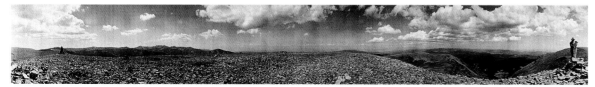

Vision itself has its history, and the revelation of . . . visual strata must be regarded as the primary task of art history.— Heinrich Wolfflin[1]

Anyone who travels in the United States sooner or later encounters a sign announcing a scenic overlook. Pulling into a parking lot, we find ourselves standing on a cliff or promontory, or at the top of a hill or mountain looking down at an extended vista. We may feel overwhelmed by the vastness of the scene, perhaps even a touch of vertigo as we stare at the Pacific Ocean from a cliff north of Big Sur or at the Hudson River making its way through the flatlands of the Hudson Valley from a pull-off high in the Catskill Mountains. Yet if the experience of the panoramic is often dizzying and overwhelming, its attraction is undeniable. On a first visit to New York City, a trip to the top of the Empire State Building or the World Trade Center is de rigueur. When it comes to the American Grand Tour, no journey is complete without visiting the Grand Canyon and Niagara Falls—both characteristically viewed from a cliff or promontory that gives onto a vast, open space.

Not only do tourists encounter the panoramic at scenic overlooks, skyscraper observatories, and historic natural wonders, but also at mountaintop parks and viewing towers. Tourists and hikers climb mountains not simply for the exercise but for the breathtaking view from the summit. And often they discover a viewing tower at the top of the mountain along with pay-per-view binoculars that provide them with an opportunity to scrutinize the surrounding terrain in minute detail.

Because the panoramic has become so much a part of vacations and tourism, we tend to take it for granted. We may only rarely visit a man-made panorama—the Cyclorama at Gettysburg, for example, or the movie panorama at Disneyland with its spectacular aerial views of the Rockies and the Pacific Coast—but the panoramic is everywhere inscribed in popular culture. In the 1950s, CinemaScope elongated the standard movie format (going from a ratio of 1:1.3 to 1:2.35) to produce panoramic effects, and today most Hollywood productions are shot in successor versions of this format (e.g., Panavision). Cinerama, an even more exotic version of the panoramic motion picture, which required the use of three synchronized projectors, made its debut in 1952 in specially equipped theaters where audiences thrilled to cinematic travelogues featuring roller coaster rides and airplane flights over the Grand Canyon. Today the IMAX film, Cinerama's successor, overwhelms audiences with enveloping views from the air, from outer space, and from underwater where cameras mounted on submarines scan the wreck of the Titanic. So much has the panoramic become a part of everyday seeing and viewing that point-and-shoot cameras now come equipped with a feature that allows us to select a panoramic format. We can even buy a disposable panorama camera. In a similar vein, high definition television (HDTV), soon to be available throughout the United States, replaces the traditional television screen (1:1.3) with a more panoramic format (1:1.75).[2]

Perhaps because the panoramic is so much a part of our visual world, we often miss its historical and cultural specificity. It seems perfectly natural to survey a landscape from the top of a mountain or inspect its details through binoculars or a telescope. And we usually think little or nothing of the fact that the film we are watching is in Panavision or CinemaScope, or the photograph we are taking will have a panoramic shape.

Scenic Overlook
A l a n W a l l a c h

Of course, the panoramic has been with us for a long time. Indeed, we might argue that throughout history, men and women have climbed to the tops of hills or mountains to scout for enemies or game, and have built watchtowers for defense. Some researchers have speculated that instinct impels us to seek the safety of a hidden vantage point overlooking surrounding territory. Still, the type of experiences I have been describing—climbing a mountain for the view or taking the elevator to the top floor of the World Trade Center—involve cultural practices determined by the conditions of modern life. Here it is necessary to distinguish between cultural stages: for it is one thing to build a watchtower to dominate, visually, the surrounding terrain, quite another to impose or project an aesthetic on a landscape view. Indeed, the panoramic mode of vision becomes possible only with the invention of the panorama—a type of entertainment that first appeared in London in 1789.

Robert Barker created the first large-scale panorama; the word panorama—meaning, literally, all-seeing (from the Greek *pan* + *horama*)—was coined a few years later.[3] Typically, panorama paintings were exhibited in specially designed rotundas. To view the cylindrical painting, spectators climbed a tower, located at the center of the rotunda, to a viewing platform. The viewing platform was positioned in such a way that the painting's horizon line roughly coincided with the spectators' eye level, which meant that spectators experienced a sensation of looking down at the scene. This was only one of several carefully calculated visual effects. The painting was illuminated by hidden skylights while the rotunda and its contents (the tower, the viewing platform) remained shrouded in darkness. The resulting contrast between light and dark, between the painting and the ghostly or insubstantial realm inhabited by the spectators—who thereby became anonymous and invisible witnesses to the scene—produced a powerful trompe-l'oeil effect, making the painting the only visible "reality." All this staging was done to maximize visual drama since spectators did not casually come upon the painting but emerged from the shadowy space of the tower onto the viewing platform where the painting suddenly burst upon them. Early panorama visitors often found this moment of sublimity overwhelming. (A visit to a panorama could result in dizziness and "Sehkrank," or see-sickness[4]) The panorama might thus be thought of as a machine or engine of sight in which the visible world was reproduced in a way that hid or disguised the fact that vision required an apparatus of production. What was being produced was in the end not only a spectacle but a spectator with a particular relation to "reality."

Stephan Oettermann has argued that the invention of the panorama belongs to a period in which new forms of middle-class hegemony arose and that the panorama itself encoded these forms. Consequently, Oettermann along with Michel Foucault has linked the panorama to Jeremy Bentham's almost contemporaneous invention of the panopticon (the word also translates as *all-seeing*), a circular prison with a tower at its center designed for the constant surveillance of inmates.[5] In the panopticon, inmates were subject to an anonymous authority, "the eye of power," or "sovereign gaze," as Foucault has called it, that emanated from the tower. The sovereign gaze represented a new equation between vision and power—power that now aspired to total domination. The panorama embodied a similar aspiration. In the panorama, the world is presented as

a form of totality; nothing seems hidden; the spectator, looking down upon a vast scene from its center, appears to preside over all visibility.[6] This totalizing vision might be called "panoramic"; however, the term "panoptic" is preferable for two reasons. First, it underscores the connections between vision and power: the ascent of a panorama tower provided the visitor with an opportunity to identify, at least momentarily, with a dominant view—Foucault's "eye of power." The second reason has to do with the mode of vision itself. That mode was both extensive and intensive, therefore it needs to be distinguished somewhat from the usual meanings associated with the word "panorama." It was extensive or "panoramic" in the everyday sense of that term because it covered the entire lateral circuit of visibility, but it was also intensive or telescopic because it aspired to control every element within the visual field— precisely the point of Bentham's panopticon.

Having reached the topmost point in an optical hierarchy, the viewer experienced the "panoptic sublime," a sudden access of power, a dizzying sense of having suddenly come into possession of a terrain stretching as far as the eye could see. The ascent of the panorama tower was in this respect a stunning metaphor for social aspiration and dominance. The way in which social meanings were projected onto landscape—were absorbed into the forms of landscape—were quite literally naturalized—should obscure neither the historic roots nor the historical specificity of the process. To the viewer the panoptic sublime was primarily a matter of vision; however, it was something else as well. The panoptic sublime drew its explosive energy from prevailing ideologies in which the exercise of power and the maintenance of social order

required vision and supervision, foresight and, especially, oversight.

What happened inside the panorama rotunda was quickly translated to the experience of actual landscapes. It is no accident that the whole development of landscape tourism in the United States in the first half of the nineteenth century revolved around sites famous for their panoramic views. Niagara Falls, although at first difficult to reach, began attracting tourists as early as 1800. Access was greatly enhanced by the opening of the Erie Canal in 1825. By 1840 visitors could take in the cataract and the surrounding scenery from a viewing tower rising above the precipice of Horseshoe Falls.[7] Monte Video, a country estate belonging to Daniel Wadsworth, a retired Hartford financier, was opened to the public—or at least those who could get there by carriage or on horseback—as early as 1810. Located on the summit of Talcott Mountain eight miles west of Hartford, Monte Video—literally the Mount or Hill of Vision—featured elaborate gardens, a boathouse, an icehouse, a tenant farmer and a working farm, and a fifty-five foot viewing tower that afforded a spectacular view extending ninety miles in all directions.[8] The summit of Mount Holyoke, Massachusetts, was another frequent destination. Opened as a tourist attraction in 1821 by the city fathers of Northampton, who had a carriage road built to the summit, Mount Holyoke rewarded visitors with sweeping views of the famous oxbow on the Connecticut River and the pastoral valleys beyond.[9] Among landscape resorts of the period, the Catskill Mountain House, which opened in 1824, was undoubtedly the most famous and the most popular. Perched high on an escarpment overlooking the Hudson Valley, its renowned view of the Hudson River and the distant Berkshire mountains to the east attracted writers and artists

(Thomas Cole and Frederic Church were visitors) along with well-to-do tourists from all along the eastern seaboard.[10]

The extent to which the experience of landscape was identified with the aesthetics of the panorama in the early years of the nineteenth century is suggested by a letter Thomas Cole wrote to his patron Daniel Wadsworth in August 1827 describing his ascent of Red Mountain in New Hampshire. Here the conventions of panoramic viewing operate like a reflex:

> I climbed [Cole wrote] without looking on either side [in other words, as if he were climbing the tower of a panorama]: I denied myself that pleasure so that the full effect of the scene might be experienced—Standing on the topmost rock I looked abroad!—With what an ocean of beauty, and magnificence, was I surrounded.[11]

As landscape tourism focused on the experience of the panoramic or panoptic sublime, so landscape painters increasingly attempted to replicate in their work the experience of panoramic vision. Actual panoramas were at best risky investments and consequently relatively few were built.[12] Instead, beginning in 1836 with Thomas Cole's spectacular *View from Mount Holyoke, Northampton, Massachusetts, After a Thunderstorm*, popularly known as *The Oxbow* (Metropolitan Museum of Art), American landscape artists attempted to replicate panoramic effects working on traditional two-dimensional surfaces and employing conventional formats (usually a height-to-width ratio of slightly less than two to three). In *The Oxbow*, Cole managed to compress or jam together two related vistas, producing a sense of panoramic breadth. The viewer looks down upon the scene as if from a great height, an effect that is intensified by the deliberate upward tilt of the ground plane as it recedes towards the distant horizon. And because Cole introduced seemingly endless details—a flight of birds, boats on the river, figures in the boats, a horse and rider, figures working in the fields, rows of haystacks, herds of cattle, dozens of houses, each with its own chimney and plume of smoke, etc.—the viewer confronts a scene that is both panoramic and telescopic, vast and yet minutely rendered.[13]

The panoramic or panoptic convention, as it might be called, can be considered the defining feature of Hudson River School landscape painting. Beginning with Cole, such artists as Frederic Church, Jasper Cropsey, Albert Bierstadt, and Thomas Moran attempted to outdo each other in evoking the panoptic sublime. For example, in his famous painting of Niagara Falls (1857, Corcoran Gallery of Art), Church set out to astonish and overwhelm his audience through the modification and intensification of already-familiar conventions and techniques. Church took the photographic image as his model of representational truth and consequently his painting can be read as an effort to embody an impersonal or as it were photographic ideal of objectivity in which the artist toils heroically to eliminate from the surface of his canvas all traces of the labor involved in producing an image. The result is a slick or licked surface that signals transparency (but also results in a rather hard and shiny effect in the foreground).[14] Church thus finds his place within a history of the Hudson River School's stylistic evolution in which representing the Real had become the object of a sort of entrepreneurial competition—a history that in some respects recalls successive developments

in motion picture technology in the twentieth century: Technicolor, CinemaScope, and so forth.

Church enjoyed the status of "national painter" during the years immediately preceding the Civil War. Later, Bierstadt and Moran dominated with their portrayals of western scenery. Bierstadt became known for his hyper-real views of Yosemite, Moran for outsize canvases depicting Yellowstone and the Grand Canyon of the Colorado. In these paintings, Moran pushed the panoramic convention to its limits in attempting to replicate on canvas the vastness of the American west.

With these works, the Hudson River School all but exhausted its technical resources. As an enlarged and more heterogeneous art world developed after the Civil War, the Hudson River School painters fell out of fashion, eclipsed by such artists as Winslow Homer, George Inness, Albert Pinkham Ryder, and John Singer Sargent, who pursued far more personal or subjective concepts of the relation between art and nature. Simultaneously, the art world became a more exclusive place as distinctions between high and popular art began to take hold. The panoramic remained identified with forms of popular entertainment, with public spectacles, not the subtleties of individual perception and the artist's unique sensibility, qualities that appealed to the few who possessed the ability necessary to appreciate them. By the early 1880s, Church, Bierstadt, and Moran had become relics of an earlier age when an artist could represent the nation's past and future on a single panoramic canvas.

The panoramic was always associated with popular or mass entertainment and it is in those forms that it primarily survives today— in photography, in film, and in television. Moreover, landscape tourism remains inseparable from visual representations of the panoramic. If the scenic overlook encourages us to see the American landscape as a panorama, we do so only because we have already seen so many panoramic images of America.

From the viewpoint of this history, Gus Foster's photographs of the Rockies attest to the continuing link between the panoramic and the sublime. Foster is a fine, not a popular artist, and his work, seen mainly in art gallery exhibitions, appeals to a relatively specialized audience. Nonetheless, his extended format views taken from peaks in the Rocky Mountains recapitulate the achievements of the Hudson River School painters and a continuing fascination with the panoramic. The extended vistas, the precise details of his photographs remind us of the paintings of Church and Moran but with this difference: Foster's panoramas speak to a far more austere and far less nationalistic concept of the sublime. Views of almost inaccessible places—places far removed from the usual tourist routes and untouched by the meanings we continue to invest in tourist landscapes—they do little to diminish or ease the strangeness of the scenes portrayed. ■■■

Alan Wallach is Ralph H. Wark Professor of Art and Art History and Professor of American Studies at the College of William and Mary, and most recently the author of Exhibiting Contradiction: Essays on the Art Museum in the United States *(University of Massachusetts Press, 1998).*

NOTES

1. Heinrich Wolfflin, *Principles of Art History: The Problem of the Development of Style in Later Art,* trans. M. D. Hottinger (1915; reprint, New York: Dover Publications, 1950), 11. **2.** I am indebted to my colleague, Professor Arthur Knight of the College of William and Mary, for information about television and movie screen formats and details of the history of Cinerama and CinemaScope. **3.** For the sake of my argument I have in this paragraph and the two that follow drawn upon material in Alan Wallach, "Making a Picture of the View from Mount Holyoke," in David C. Miller, ed., *American Iconology: New Approaches to Nineteenth-Century Art and Literature* (New Haven: Yale University Press, 1993), 80–91. The most comprehensive history of the panorama is Stephan Oettermann, *The Panorama: History of a Mass Medium,* trans. Deborah Lucas Schneider (1980; reprint, New York: Zone Books, 1997). See also Ralph Hyde, *Panoramania!: The Art and Entertainment of the "All-Embracing" View* (London: Trefoil, 1988); and [G. R. Corner], "The Panorama: With Memoirs of its Inventor, And His Son, The Late Henry Aston Barker," *The Art-Journal,* new ser. 3 (February 1857): 46–47; and essays by Marie-Louise von Plessen, Bruno Weber, Scott Wilcox, Stephan Oettermann, Kevin Avery, et al., in *Sehsucht: Das Panorama als Massenunterhaltung des 19. Jahrhunderts* (Bonn: Stroemfeld/Roter Stern, 1993). **4.** Oettermann, *The Panorama,* 12–13. **5.** See Oettermann, *The Panorama,* 40–44; and Michel Foucault, *Discipline and Punish: The Birth of the Prison,* trans. Alan Sheridan (New York: Vintage Books, 1979), 195–228, 317 n. 4; and Michel Foucault, "The Eye of Power," in *Power/Knowledge: Selected Interviews and Other Writings, 1972–1977,* ed. Colin Gordon, trans. Colin Gordon, Leo Marshall, John Mepham, Kate Soper (New York: Pantheon Books, 1980), 146–165. Foucault speculates that Bentham may have been inspired by Barker's panorama but Bentham's own account seems to preclude this. See Jeremy Bentham, "Panopticon or The Inspection-House" in John Bowring, ed., *The Works of Jeremy Bentham* (Edinburgh: William Tait, 1843; London: Thoemmes Press, 1997), 4: 37–172. For a recent analysis see Robin Evans, "Bentham's Panopticon, An Incident in the Social History of Architecture," *Architectural Association Quarterly* 3, no. 2 (April–July 1971): 21–37. **6.** It is impossible in a short article to develop the historical bases for equations between vision and power in landscape painting, although I would observe that the equation was never as abstract as it appears to be in Foucault's writings. It should also be said that in landscape painting the equation evolves from an identity between sight or vision and land ownership to metaphorical forms in which landscape comes to signify "a well-constructed survey of the nation's prospects" as seen through the eyes of an aristocratic elite. See James Turner, *The Politics of Landscape: Rural Scenery and Society in English Poetry, 1630–1660* (Oxford: Basil Blackwell, 1979); and "Landscape and the 'Art Prospective' in England, 1584–1660," in *Journal of the Warburg and Courtauld Institutes* 42 (1979): 290–293; and Carole Fabricant, "The Aesthetics and Politics of Landscape in the Eighteenth Century," in Ralph Cohen, ed., *Studies in Eighteenth-Century British Art and Aesthetics* (Berkeley: University of California Press, 1985), 49–81. **7.** See Elizabeth R. McKinsey, *Niagara Falls: Icon of the American Sublime* (New York: Cambridge University Press, 1985); and John F. Sears, *Sacred Places: American Tourist Attractions in the Nineteenth Century* (New York: Oxford University Press, 1989), 12–30. **8.** See Alan Wallach, "Wadsworth's Tower: An Episode in the History of American Landscape Vision," *American Art* 10, no. 3 (Fall 1996): 8–27. **9.** See Wallach, "Making a Picture of the View from Mount Holyoke." **10.** See Roland Van Zandt, *The Catskill Mountain House* (1966; reprint, Cornwallville, New York: Hope Farm Press, 1982; Hensonville, N.Y: Black Dome Press, 1997); and Kenneth Myers, *The Catskills: Painters, Writers, and Tourists in the Mountains, 1820–1895* (Yonkers: The Hudson River Museum of Westchester, 1987). **11.** Thomas Cole to Daniel Wadsworth, August 4, 1827, in Bard McNulty, ed., *The Correspondence of Thomas Cole and Daniel Wadsworth* (Hartford: The Connecticut Historical Society, 1983), 10–11. **12.** See Oettermann, *The Panorama,* 313–344; see also Kevin Avery, "The Panorama and its Manifestations in American Landscape Painting" (Ph.D. diss., Columbia University, 1995). It is perhaps noteworthy that the first circular panorama exhibited in the United States was Ralph Earl's *Niagara Falls,* which the artist displayed in 1800 in Northampton, Massachusetts, New Haven, Connecticut, and at the Peale Museum in Philadelphia. See Elizabeth Mankin Kornhauser, *Ralph Earl* (Hartford: The Wadsworth Atheneum; New Haven: Yale University Press, 1991), 62–65. **13.** See Wallach, "Making a Picture of the View from Mount Holyoke." **14.** For Church's *Niagara,* see David Huntington, *The Landscapes of Frederic Edwin Church: Vision of an American Era* (New York: George Braziller, 1966), 1–9, 60–71; and Jeremy Elwell Adamson, "Frederic Church's *Niagara:* The Sublime as Transcendence" (Ph.D. diss., University of Michigan, 1981); and Adamson et al., *Niagara: Two Centuries of Changing Attitudes, 1697–1901* (Washington, D.C.: Corcoran Gallery of Art, 1988).

The Rocky Mountains extend from New Mexico through the continental United States and finally terminate in the Yukon Territory near Alaska. My photographs of the American Rockies exhibit a body of work that evolved from my enjoyment of outdoor life, and from the outdoor experiences that shape and give focus to my life. Before I moved to New Mexico in the mid-70s I knew the Rockies only as the spectacular scenery I passed through on highway trips. My photographs back then were of people, and my outdoor experiences revolved around the rivers, lakes, and woods of northern Wisconsin—great hardwood and pine forests, abundant waterways, but essentially flat and no comparison to mountains. My home now is in Taos, New Mexico, situated at the edge of the Sangre de Cristo range of the Rockies. I live in the middle of town, yet I am less than ten minutes away from the forest, less than half an hour away from being above 9,000 feet elevation, and under an hour from the boundary of a true wilderness area nearly a quarter million acres in size.

In the last twenty years, I've spent hundreds of hours walking, hiking, and climbing in the Sangre de Cristos—getting to know my "back yard." I have also learned many of the skills essential to survival in the mountain wilderness. Early in my climbing career a friend's gift allowed me to participate in an intensive Outward Bound program in winter mountaineering. I learned survival skills, ice climbing, mountaineering, skiing, and I climbed one of the Colorado "fourteeners," in January. One summer, in the Pecos Wilderness, I witnessed a rescue in progress; a hiker had fallen and broken her leg. Observing a rescue operation made me realize that every person in the wilderness becomes a member of a new "community." The assistance we too often take for granted in our cities and towns—the 911 telephone number for instance—is not available in the wilderness. A rescue operation becomes a far more serious matter. Realization of this need for "community" in the wilderness led me to become a member of the Taos Search and Rescue team. For eight years I learned, trained, and practiced vital survival and rescue skills: tracking, map and compass, swiftwater rescue technique, rope work, wilderness medicine, all the common sense "do and don't" skills that often make that critical difference in the outdoors.

Thinking back, I'd say that part of my attraction to mountaineering in the Rockies began with a chair. In 1977, I took a railroad trip across the Canadian Rockies with my children and their grandmother. Our trip ended in Banff, Canada, where my girlfriend met up with us. My family flew home, and before driving to New Mexico my girlfriend and I wandered around Banff antiquing; we chanced upon a wonderful, decades old, bent-alderwood chair at a trading post. The chair wasn't for sale, but the owners allowed us to photograph it. When we returned to Taos we discovered, by chance, some furniture made by a local artist that was similar in style to the chair we had hoped to own. We eventually tracked the furniture maker down, discovering that he lived on the edge of the national forest near the Pecos Wilderness. We made an appointment to visit him and on the road to his place our vehicle got so completely stuck in the mud he had to put us up for the night. Thus began a friendship that continues to this day. Roger Badash made a version of that chair for me, and more importantly, he subsequently introduced me to wilderness backpacking using burros. I've often thought of burro packing as being the "Rolls-Royce" of backpacking; my hiking companions and I are

View from the Top
G u s F o s t e r

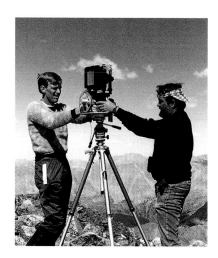

Tom Simons, left and Gus Foster on
Mt. Yale Summit, 1987
Photo by Josie Foster

able to travel on foot at a leisurely pace, but we don't have to carry all our own gear. With pack burros I have the luxury of bringing along a camp stove, a frying pan, fresh foods, and a bottle of wine to celebrate a successful climb. Burros, and more recently a goat, also enable my partners and me to trek deeper into the wilderness, and to save our strength for climbing the mountains. We can spend as much as a week devoted to the climb of a single peak without straining our resources, and we can contemplate excursions of up to three weeks without having to resupply. Our four-legged companions make mountaineering, with heavy photographic equipment, possible.

In 1979, I used a #10 Cirkut camera to make panoramic photographs. That camera, first manufactured in 1902, was a heavy, cumbersome device, never intended for use in the mountains. Employing ten-inch roll film, it had a spring-driven motor, and a series of gears that propelled it around a ring gear mounted on a wood tripod. The panoramic photograph it produced was ten inches high by six feet wide. Like many other eighty-year-old devices, it was unpredictable and did not always function well. Badash, a group of friends, and I climbed Jicarita Peak in the Pecos Wilderness in the early fall of 1979. Roger's burros, Stewball and Maggie, helped us pack our gear to tree line, and all six of us helped carry the various wooden cases containing the camera to the 12,800-foot summit.

I continued to use the Cirkut camera for a few more years, adding a color aerial film I had adapted for use in this camera in 1981. In that year, I also started using a 35mm panoramic camera invented and produced by Ron Globus. Called a Globuscope, this camera weighed a mere five-and-a-half pounds, and made a 360 degree revolution in less than one second.

Because of the fast speed and light weight it could be used as a hand-held camera, eliminating the need for a tripod.

About this time I started climbing with Tom Simons, an energetic mountaineer/human dynamo who, as a warmup to one of our ascents, ran the twenty-six-mile mountain marathon from Ouray to Telluride, Colorado, a marathon whose course goes up and over the 13,000 foot Imogene Pass. After seeing my photograph of Jicarita Peak, Tom suggested that I go see a "real" mountain with him. He offered to carry my camera, saying that all I would have to do was "get my own fat butt up the hill." I accepted Tom's challenge and offer. In the summer of 1982 we climbed the 14,048 foot Handies Peak in the San Juan Range of the Colorado Rockies. What an awesome view! I was hooked, and almost instantaneously gained a new perspective on the world from its mountaintops. In fairness to Jicarita, though, and in deference to Tom, I must say that Jicarita's summit is so broad that the surround and the extraordinary vistas can not be taken in from one place, a contrast to the much smaller summits of Handies Peak and subsequent peaks I have visited.

In 1985, Ron Globus invented a new camera in collaboration with Donal Holway. The Globus-Holway uses five-inch film that results in a negative significantly smaller than the old Cirkut's. The impressive advances the designers made in optics and engineering also enabled the camera to produce superbly sharp negatives. Although the Cirkut negatives resulted in contact photographic prints of fairly large size, with this new camera I could develop a negative capable of being enlarged to a truly grand scale—a scale essential to the magnitude of the landscapes I was photographing. I devoted two years to building the enlarger and the dark-

room where I created the panoramic photographs shown in the current exhibition. More compact than the clunky Cirkut camera, the Globus-Holway was not made with mountain climbing in mind, though. With its tripod and support gear stowed in a backpack, the equipment weighs sixty-five pounds—not my favorite weight to be carrying to high places.

Viewing this planet from the top of a mountain is always an extraordinary experience for me. Each mountaintop offers a truly unique vantage point, and provides a continuous image of the distant horizon with nothing between me and that horizon line but air. I will never tire of these exhilarating moments at a mountain's apex, which must be comparable to the feelings an astronaut experiences when viewing the earth from an orbiting space shuttle. Artistically, I have always liked the 360 degree panoramic photograph, especially from a conceptual standpoint because nothing is left out of its frame. In a wilderness landscape, a panoramic camera is a unique tool with which to record a scene that extends to infinity from all points on the compass, but it can only begin to suggest the spectacular reality of the mountain peak experience.

For the next few years, I worked with my new camera, photographing from the peaks of the Pecos Wilderness. I burro-packed with my mountaineering partner Roger, his burros Maggie and her son Sid, his and my family, and friends. In 1988, I acquired two burros of my own, Chico and a youngster named Angel. I also continued climbing in the "fourteeners" of Colorado with Tom Simons, his son Quinn, and another Santa Fean, John Chamberlain. By 1989 Tom had climbed all fifty-two of the 14,000-foot summits in Colorado. He and Quinn set their sights on higher altitudes: the Mexican volcanoes, some peaks in the Andes, and, ultimately, the Himalayan Range. So, John and I kept working at the peaks in Colorado, and venturing forth, also climbed a few mountains in the Sierra Nevada Range of California.

In 1991, I started to expand the boundaries of the places I visited, to broaden the horizons seen through my camera. During the spring of 1991, I hiked 300 miles along an ancient Japanese highway as a way to get in shape for my upcoming summertime climbing. Upon my return from Japan I did some ice climbing in Alaska's Glacier Bay. Then I drove the length of the Alcan Highway from Alaska through Canada. I met John Chamberlain in Montana where we climbed a peak in Glacier National Park. We then hiked toward a peak in the Lost Range in Idaho. I had injured myself on the Alaskan glaciers, and after the Idaho trek I could go no farther that season. I took a photo at the base of the Grand Teton's on my way home, a wonderful range I have yet to explore.

(Left to right), John Chamberlain, Chico, Jim Beckley, Sid, and Roger Badash, 1994 Wind River Range, Wyoming Photo by Gus Foster

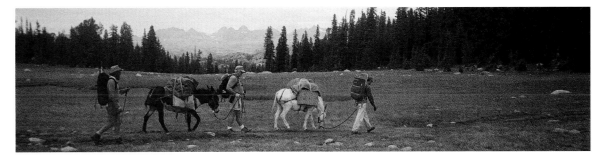

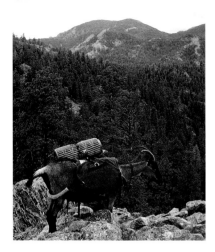

William Henry, 1998
Aldo Leopold Wilderness, New Mexico
Photo by Gus Foster

Chamberlain and I traveled to the High Uintas Wilderness Area in Utah in the summer of 1993, to climb Kings Peak. After hiking some twelve or thirteen miles we were caught in a snowstorm and spent the next forty hours huddled together in a tent with nary a book between us. During that downtime we decided we were no longer going to venture into wilderness areas carrying our own gear. I had a perfectly good burro team in New Mexico, and I began to figure out the logistics of bringing the burros on the road with me. I had also started a correspondence with a fellow in Wyoming who used goats as pack animals. I made the commitment, lying in that tent in Utah, to someday add pack goats to my hiking team. The next summer, John, Roger, and I, along with Roger's burro Sid and my Chico, returned to Utah to complete the ascent of Kings Peak. While hiking with our pack-burros, John and I kept looking at each other; we now realized that last year, without the right gear and equipment, it would have been stupid and dangerous to have persisted. We had no chance of making it to the top. The snow had kept us from true folly.

The planning of my climbing journeys evolved significantly; by the end of one season of climbing, my partners and I were seriously thinking about what, where, and how to proceed the following summer. The combined pressures of family demands and tight schedules meant that, at best, we could count on about nineteen to twenty-one days together, starting the day we left Taos and ending the day we returned. During the 1995, 1996, and 1997 seasons, these nineteen to twenty-one days were packed full: we drove 3,000 miles or more, and attempted climbs of at least five peaks. These peaks were in different wilderness areas, in one or more of the states of Oregon, Idaho, Wyoming, and Montana. We spent

as little as a day, or as many as five days in each of the areas. We packed in, climbed, packed out, drove, resupplied, then did it again, until it was time to return to New Mexico. Although these excursions were exhilarating, they were grueling hard work. We typically each year would walk 100 to 130 miles, and ascend and descend 30,000 to 40,000 vertical feet. Added to this was the long drive to the northern border states with 400 pounds of gear, hauling a stock trailer with two or three animals. Relaxation happened during the drive time from one trailhead to another, and during the pleasurable times we spent together at our high base camp at the end of each day.

In 1996, I acquired an Alpine-La Mancha goat and named him William Henry, in honor of W. H. Jackson, an early photographer of the American West and a member of the first Hayden survey of the Rocky Mountains. I proceeded to train William Henry to carry some of my camera gear. Then in 1997 he accompanied me, for the first time, on the long trip to the Big Horns of Wyoming and the Absaroka Range in Wyoming and Montana. In 1998, he was with me and my companions—carrying forty-four pounds of camera gear, everything except the tripod—as we traversed four wilderness areas in New Mexico.

The Rockies. The backbone of the North American continent. I love the mountains. In them, through them, and from them I continue to learn, to grow, and to mature. I love the wilderness—the solitude, the peacefulness. I love the great richly scented forests that embrace the mountains and stand as the guardian sentries I pass through into the thinning mountaintop air that enervates my body while energizing my mind. The forests yield to the alpine strata of rocks, and give way

to new varieties of plant and animal life, and to the expanding vistas, and ultimately the mountain's summit from where the view extends to forever from wherever I look. I love the mountains. They have been a source of true inspiration and a core experience from which much of my artistic energy radiates.

I recently crossed the western United States by plane. Looking out my porthole window—from a vantage point of 37,000 feet—I saw a vast range of mountains, at times cloud-enshrouded, at times crystalline and pristine, showing the familiar slate grays, snowy whites, and deep forest greens. I realized that for many people this could be their only view of the mountains. Few venture into the mountain environs that start where the roads end. Taking the time, doing the physical conditioning, acquiring the gear, and having the drive, stamina, and perseverance to get there requires a unique and purposeful individual. But a whole community of hardy individuals DOES go into those environs, and they have taught me, shown me, led me, and hiked and climbed with me. I am honored to be a member of this community. I hope my photographs convey the enormity of the space, and the emotion, great passion, and boundless love I have for the mountains. To be able to share these images gives me as much pleasure as being there. ■

Taos, New Mexico
10 December 1998

Clambering up the Cold Mountain path,
The Cold Mountain trail goes on and on:
The long gorge choked with scree and boulders,
The wide creek, the mist-blurred grass.
The moss is slippery, though there's been no rain
The pine sings, but there's been no wind.
Who can leap the world's ties
And sit with me among the white clouds?

—Han-shan (fl. 627–649)

(Left to right), Roger Badash, Gus Foster, and John Chamberlain, 1994
Wind River Range
Fremont Peak Summit, Wyoming
Photo by Jim Beckley

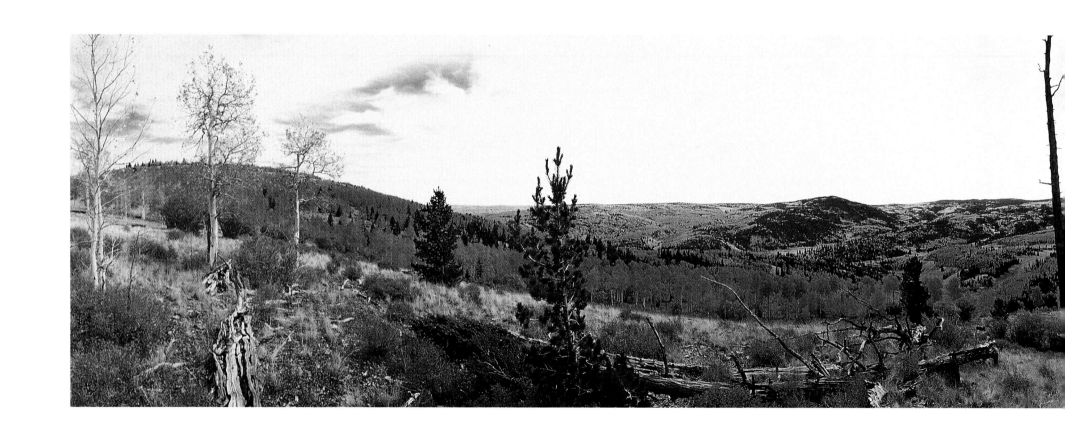

Beaver Creek Drainage, 1988, Carson National Forest, Cruces Basin Wilderness, New Mexico, 384 degree panoramic photograph

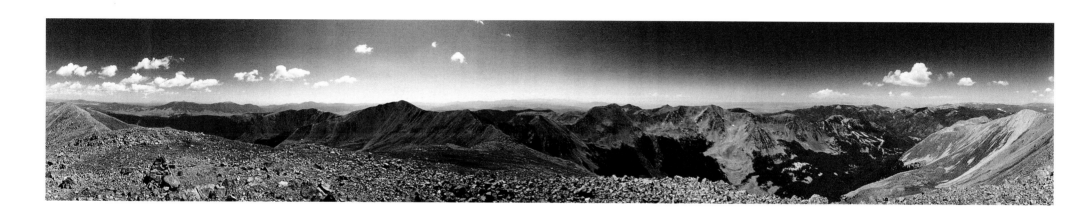

Wheeler Peak, 1987, Sangre de Cristo Range, Wheeler Peak Wilderness, New Mexico, 360 degree panoramic photograph

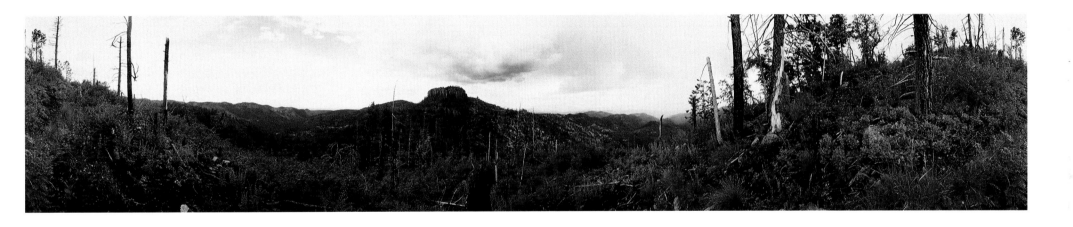

Continental Divide, 1998, Black Range, Aldo Leopold Wilderness, New Mexico, 372 degree panoramic photograph

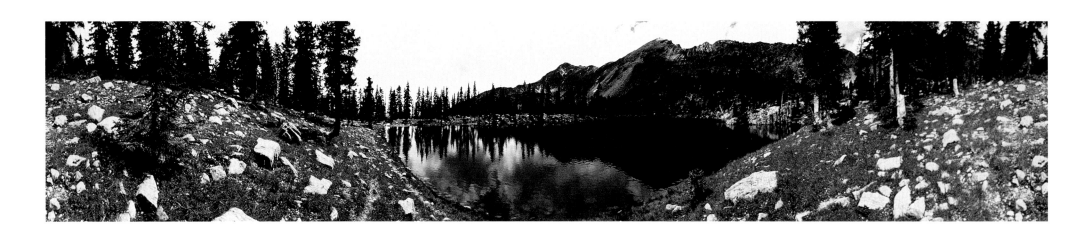

Truchas Lakes, 1986, Sangre de Cristo Range, Pecos Wilderness, New Mexico, 378 degree panoramic photograph

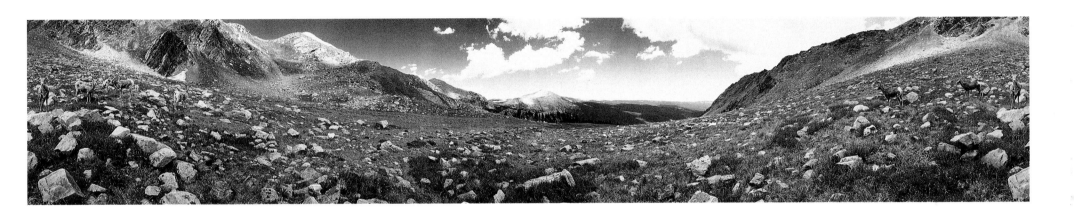

Pecos Big Horns, 1989, Sangre de Cristo Range, Pecos Wilderness, New Mexico, 376 degree panoramic photograph

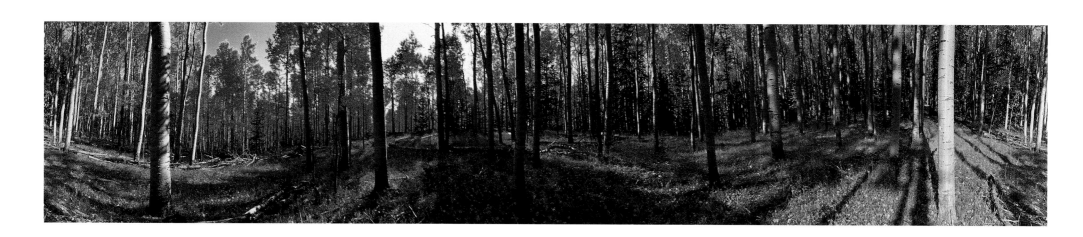

Aspens, 1993, Sangre de Cristo Range, Santa Fe National Forest, New Mexico, 375 degree panoramic photograph

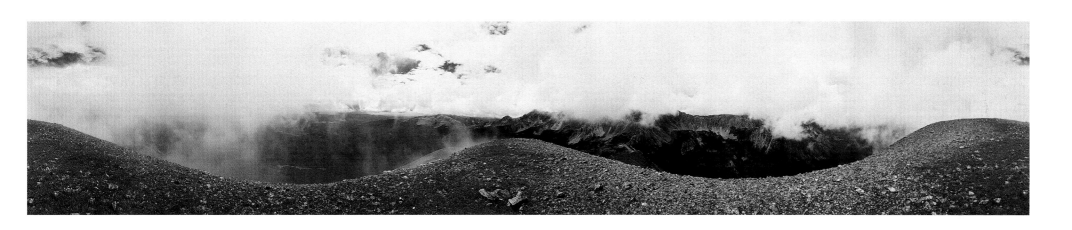

Chimayosos Peak, 1988, Sangre de Cristo Range, Pecos Wilderness, New Mexico, 376 degree panoramic photograph

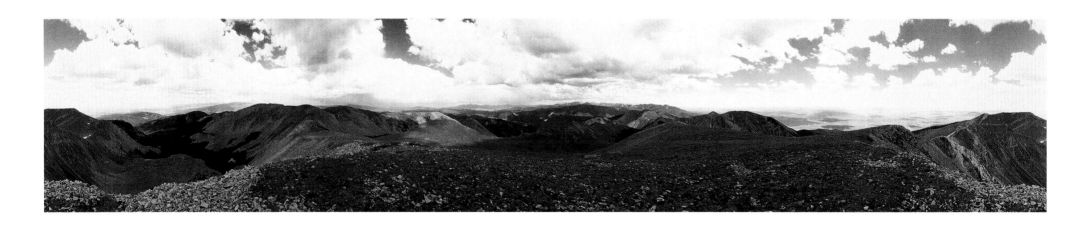

Venado Peak, 1990, Sangre de Cristo Range, Latir Wilderness, New Mexico, 380 degree panoramic photograph

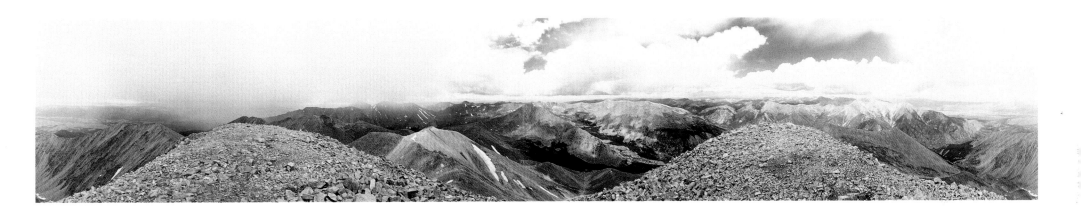

Mt. Antero, 1990, Sawatch Range, San Isabel National Forest, Colorado, 368 degree panoramic photograph

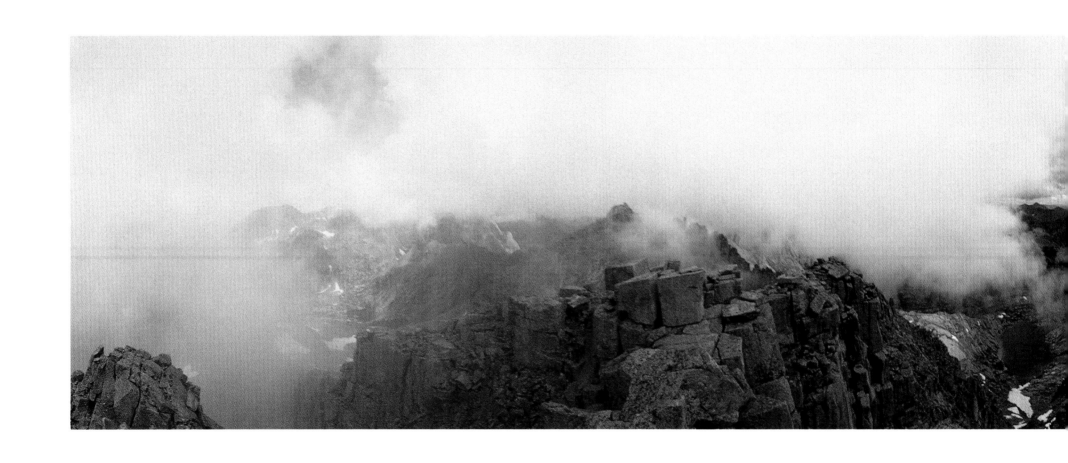

Windom Peak, 1989, Needle Mountains, San Juan Range, Weminuche Wilderness, Colorado, 378 degree panoramic photograph

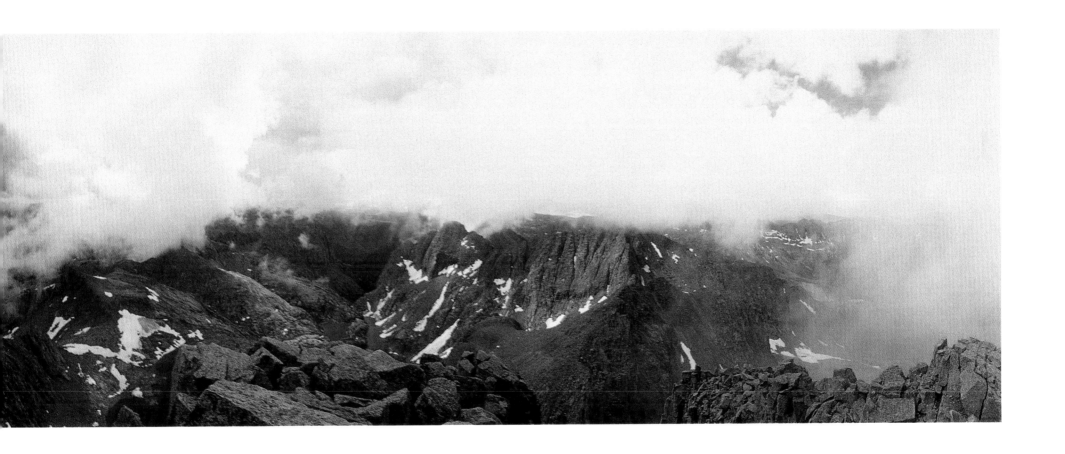

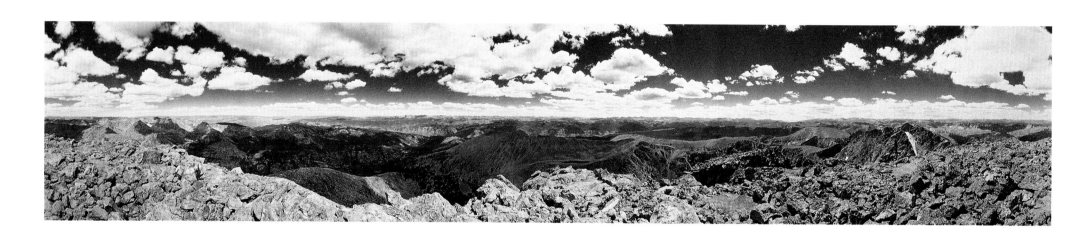

Mt. of the Holy Cross, 1988, Sawatch Range, Collegiate Peaks Wilderness, Colorado, 361 degree panoramic photograph

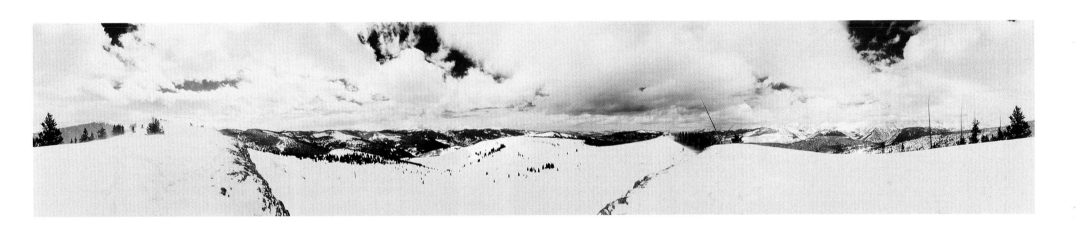

China Bowl Ridge, 1987, White River National Forest, Colorado, 376 degree panoramic photograph

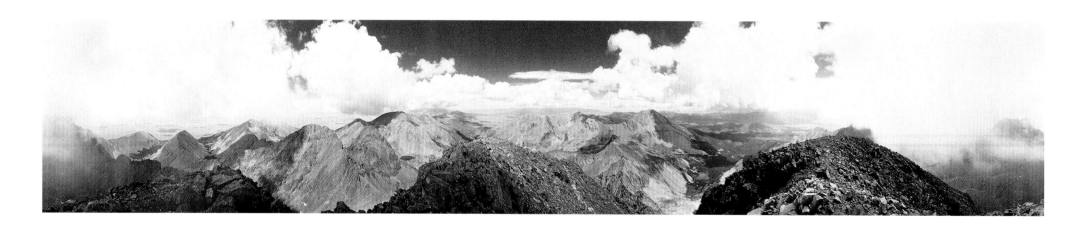

Blanca Peak, 1990, Sangre de Cristo Range, Sierra Blanca National Forest, Colorado, 388 degree panoramic photograph

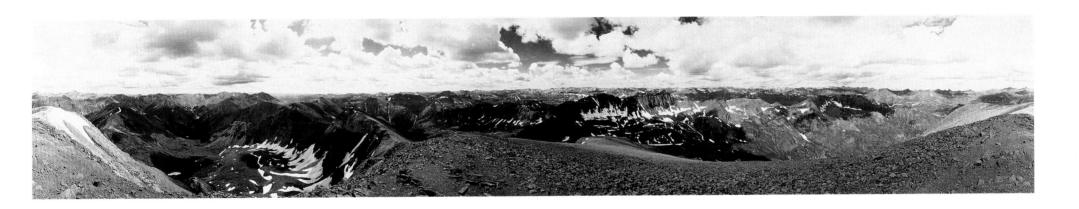

Handies Peak, 1987, San Juan Range, Gunnison National Forest, Colorado, 372 degree panoramic photograph

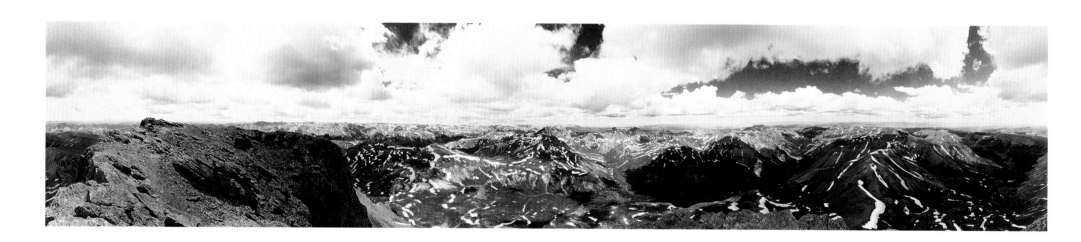

Uncompahgre Peak, 1993, San Juan Range, Big Blue Wilderness, Colorado, 364 degree panoramic photograph

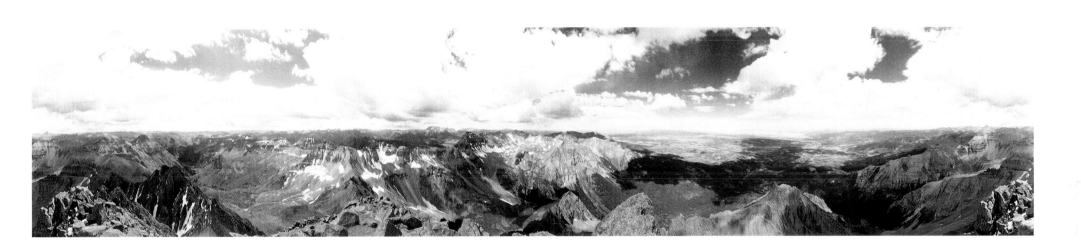

Mt. Sneffels, 1986, San Juan Range, Mt. Sneffels Wilderness, Colorado, 384 degree panoramic photograph

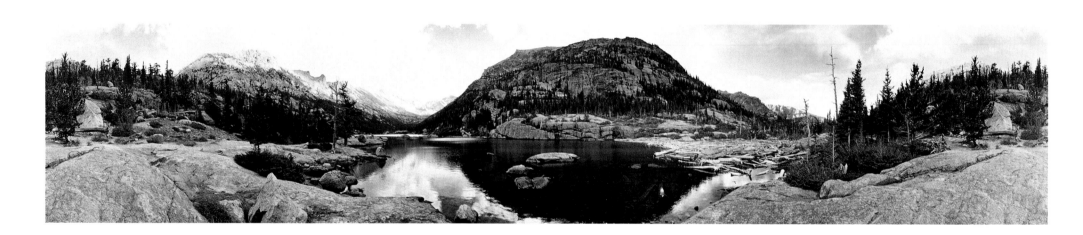

Mills Lake, 1988, Front Range, Rocky Mountain National Park, Colorado, 401 degree panoramic photograph

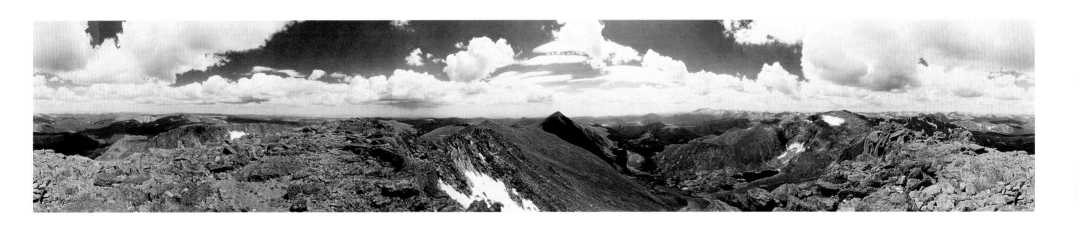

Hagues Peak, 1994, Mummy Range, Rocky Mountain National Park, Colorado, 379 degree panoramic photograph

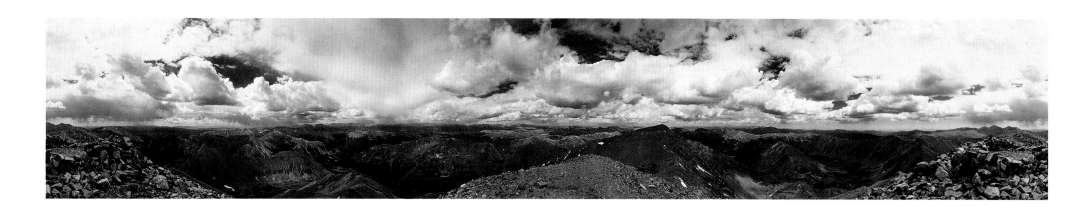

Grays Peak, 1989, Mosquito Range, Arapaho National Forest, Colorado, 384 degree panoramic photograph

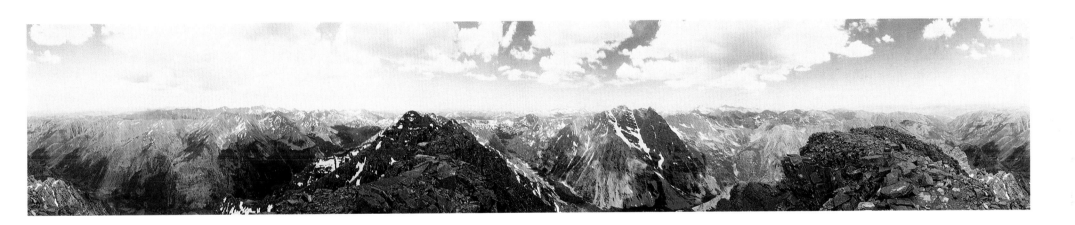

Pyramid Peak, 1989, Elk Range, Maroon Bells-Snowmass Wilderness, Colorado, 381 degree panoramic photograph

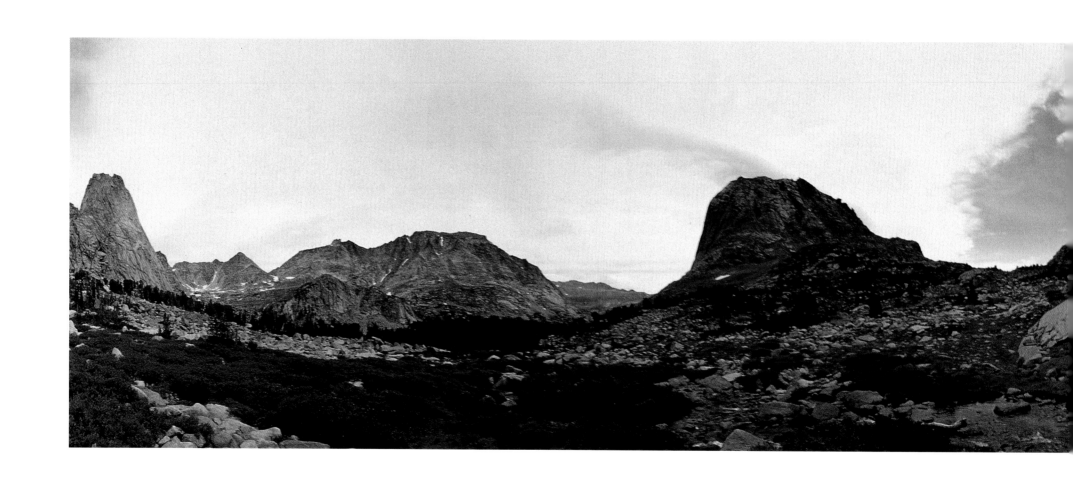

Cirque of the Towers, 1990, Wind River Range, Bridger Wilderness, Wyoming, 380 degree panoramic photograph

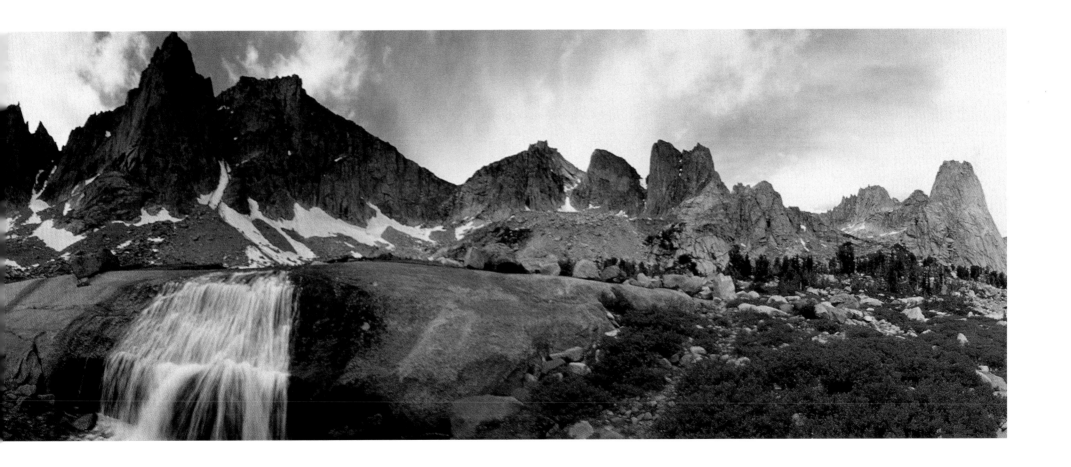

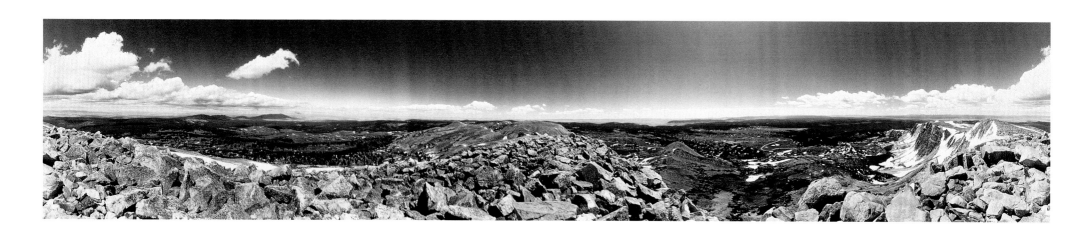

Medicine Bow Peak, 1994, Snowy Range, Medicine Bow National Forest, Wyoming, 369 degree panoramic photograph

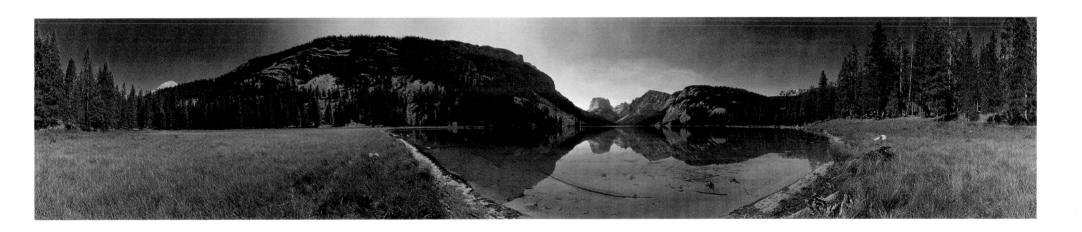

Green River Lakes, 1994, Wind River Range, Bridger Wilderness, Wyoming, 383 degree panoramic photograph

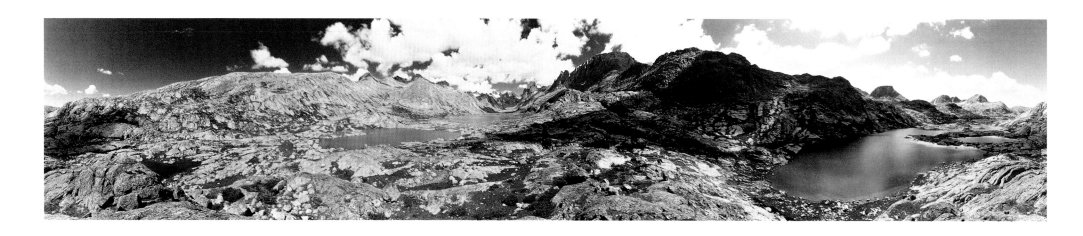

Titcomb Basin, 1994, Wind River Range, Bridger Wilderness, Wyoming, 374 degree panoramic photograph

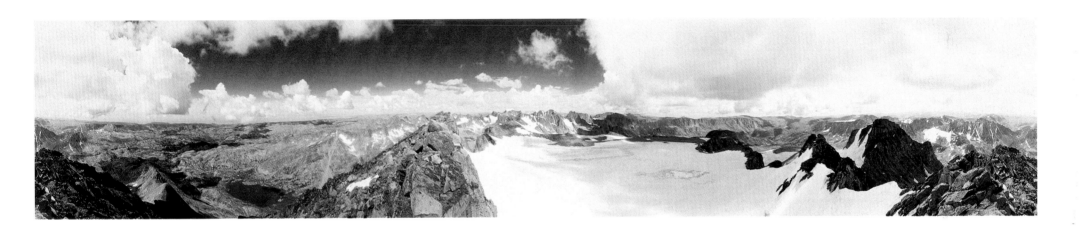

Fremont Peak, 1994, Wind River Range, Bridger Wilderness, Wyoming, 380 degree panoramic photograph

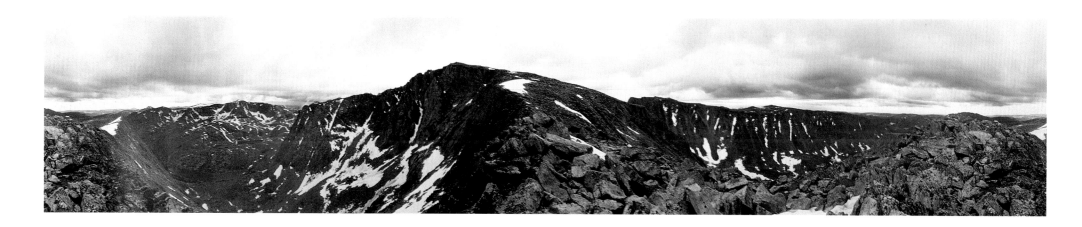

Cloud Peak Ridge, 1997, Big Horn Range, Cloud Peak Wilderness, Wyoming, 390 degree panoramic photograph

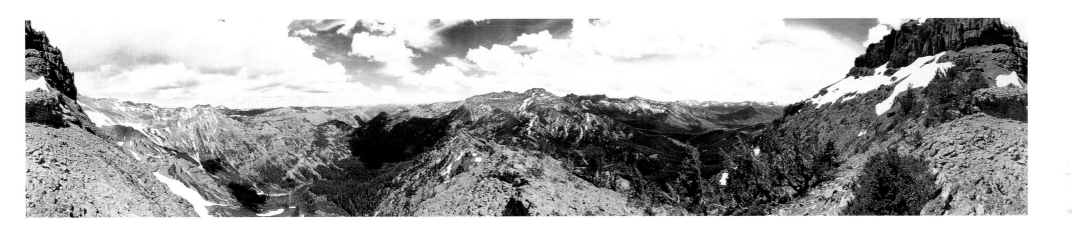

Eagle Peak Ridge, 1997, Absaroka Range, Washakie Wilderness, Wyoming, 373 degree panoramic photograph

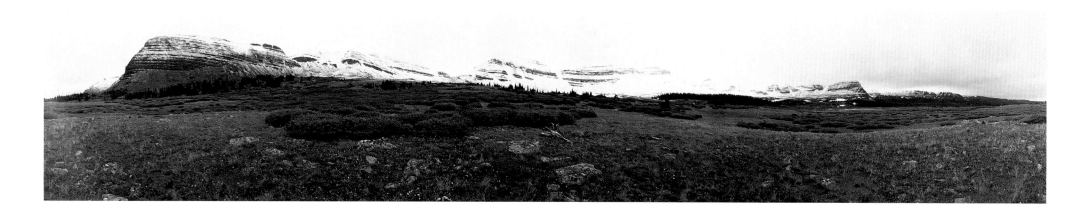

Valley Below Kings Peak, 1993, Uinta Mountains, High Uinta Wilderness, Utah, 362 degree panoramic photograph

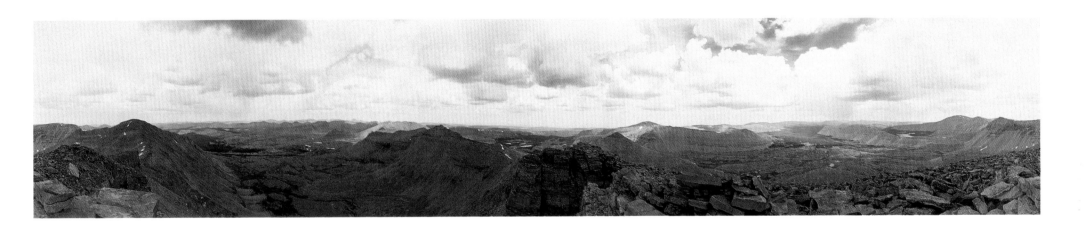

Kings Peak, 1994, Uinta Mountains, High Uinta Wilderness, Utah, 371 degree panoramic photograph

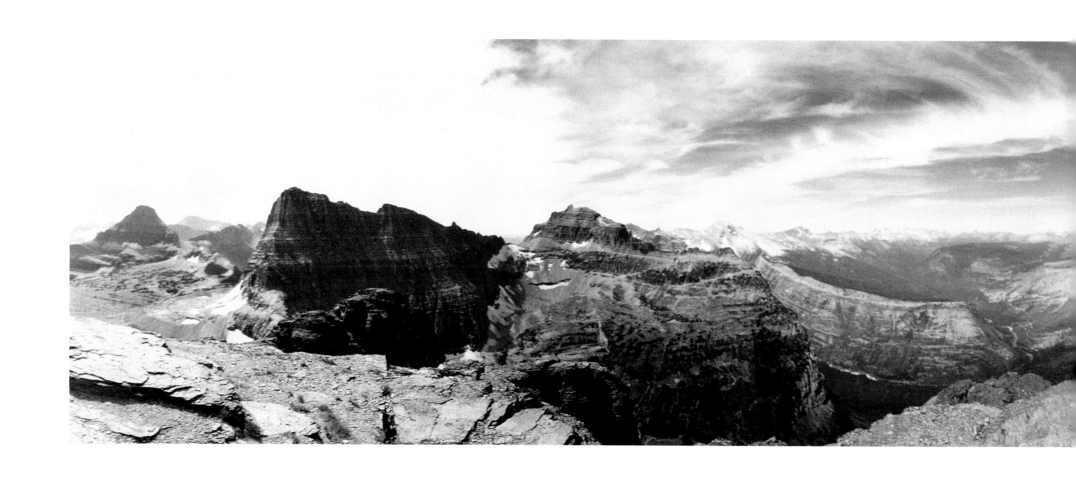

Mt. Oberlin, 1992, Livingston Range, Glacier National Park, Montana, 381 degree panoramic photograph

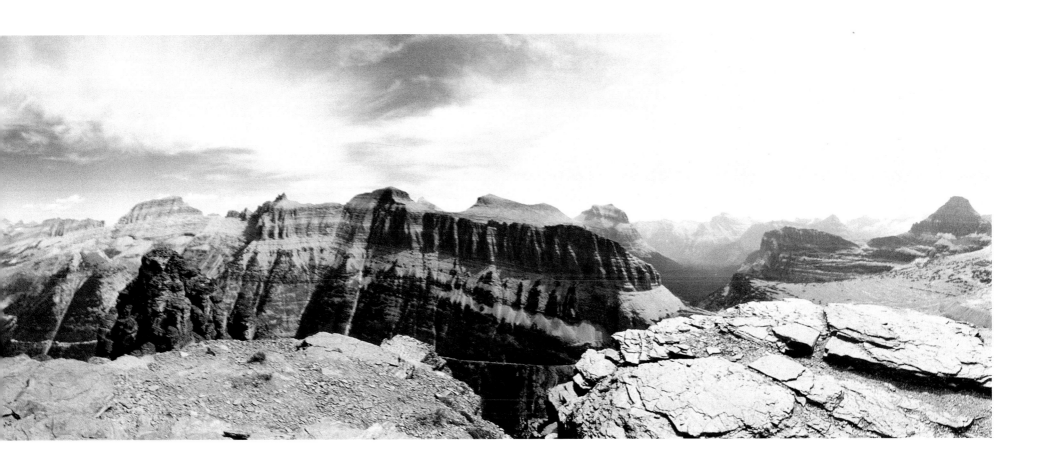

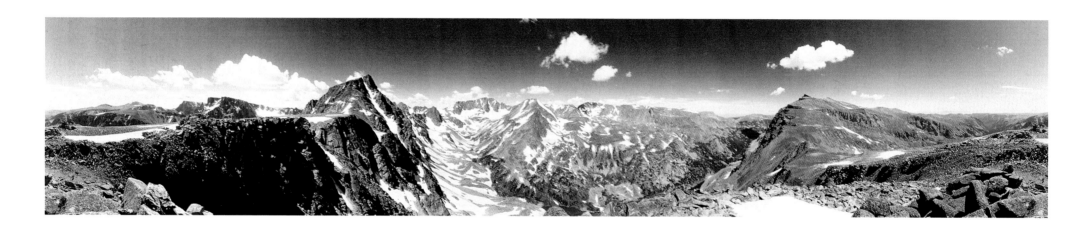

Mt. Lockhart, 1997, Absaroka Range, Absaroka Beartooth Wilderness, Montana, 375 degree panoramic photograph

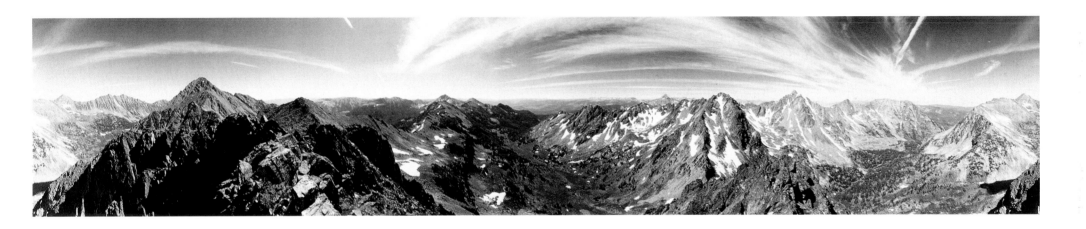

Spanish Peaks, 1996, Madison Range, Lee Metcalf Wilderness, Montana, 382 degree panoramic photograph

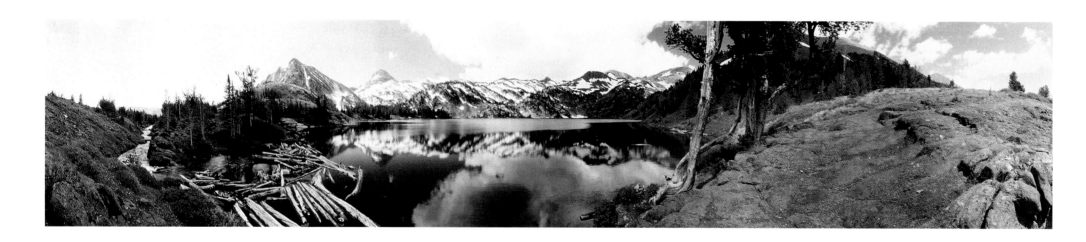

Ice Lake, 1996, Wallowa Mountains, Wallowa Wilderness, Oregon, 362 degree panoramic photograph

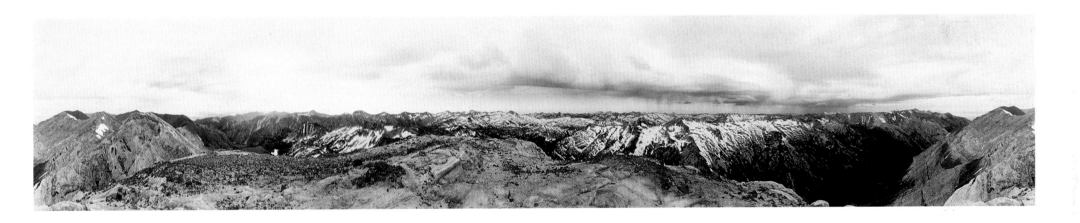

Matterhorn Peak, 1996, Wallowa Mountains, Wallowa Wilderness, Oregon, 390 degree panoramic photograph

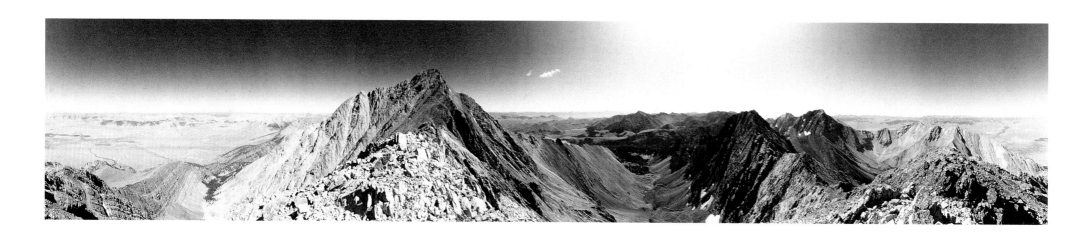

Borah Peak Ridge, 1992, Lost River Range, Challis National Forest, Idaho, 366 degree panoramic photograph

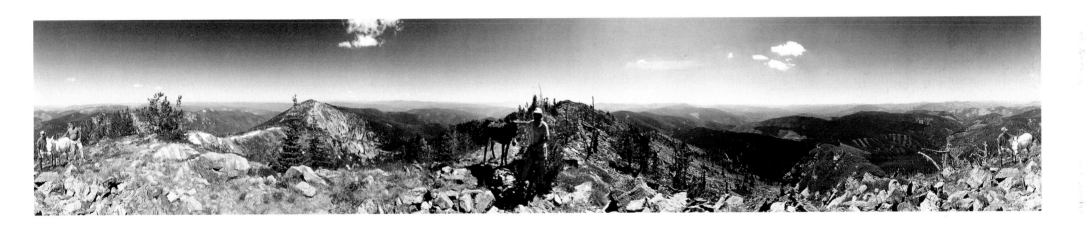

Ward Peak, 1996, Bitterroot Range, Lolo & St. Joe National Forests, Idaho, 382 degree panoramic photograph

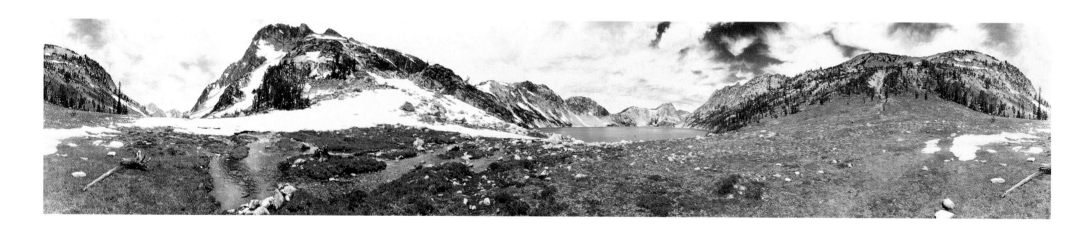

Sawtooth Lake, 1996, Sawtooth Range, Sawtooth Wilderness, Idaho, 397 degree panoramic photograph

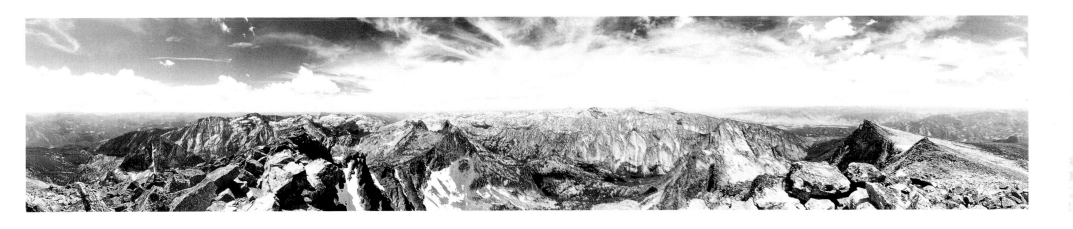

Trapper Peak, 1996, Bitterroot Mountains, Selway-Bitterroot Wilderness, Montana, 361 degree panoramic photograph

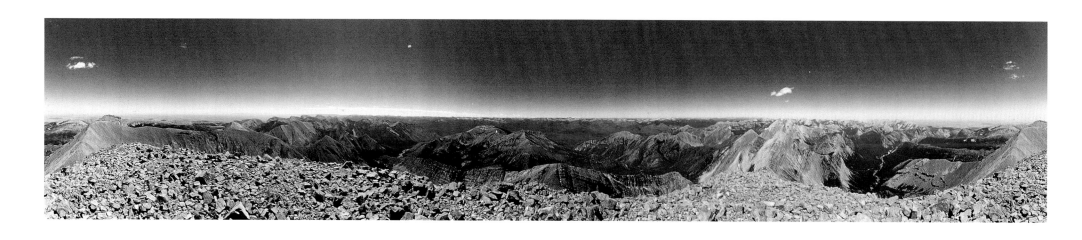

Rocky Mountain, 1995, Flathead Range, Bob Marshall Wilderness, Montana, 364 degree panoramic photograph

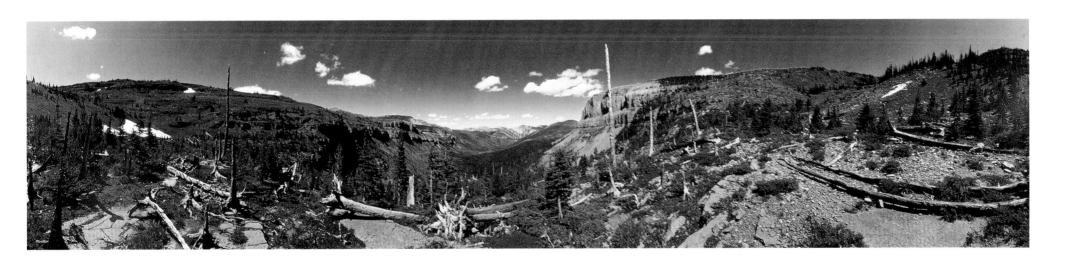

Scapegoat Wilderness, 1995, Flathead Range, Scapegoat Wilderness, Montana, 355 degree panoramic photograph

THE AMERICAN ROCKIES: PHOTOGRAPHS BY GUS FOSTER

Exhibition List

All photographs courtesy of artist except *Windom Peak*.
Photographs are Ektacolor prints.
Dimensions are frame size only.

1. *Wheeler Peak*, 1987
 Sangre de Cristo Range
 Wheeler Peak Wilderness, New Mexico
 360 degree panoramic photograph
 30" x 144"

2. *Continental Divide*, 1998
 Black Range
 Aldo Leopold Wilderness, New Mexico
 372 degree panoramic photograph
 24" x 96"

3. *Truchas Lakes*, 1986
 Sangre de Cristo Range
 Pecos Wilderness, New Mexico
 378 degree panoramic photograph
 24" x 96"

4. *Pecos Big Horns*, 1989
 Sangre de Cristo Range
 Pecos Wilderness, New Mexico
 376 degree panoramic photograph
 24" x 96"

5. *Aspens*, 1993
 Sangre de Cristo Range
 Santa Fe National Forest, New Mexico
 375 degree panoramic photograph
 30" x 144"

6. *Sandia Mountains*, 1997
 Sangre de Cristo Range
 Sandia Mountain Wilderness, New Mexico
 365 degree panoramic photograph
 16" x 70"

7. *Chimayosos Peak*, 1988
 Sangre de Cristo Range
 Pecos Wilderness, New Mexico
 376 degree panoramic photograph
 16" x 70"

8. *Venado Peak*, 1990
 Sangre de Cristo Range
 Latir Wilderness, New Mexico
 380 degree panoramic photograph
 16" x 70"

9. *Winter Solstice*, 1995
 Sangre de Cristo Range
 Carson National Forest, New Mexico
 368 degree panoramic photograph
 16" x 70"

10. *Beaver Creek Drainage*, 1988
 Carson National Forest
 Cruces Basin Wilderness, New Mexico
 384 degree panoramic photograph
 30" x 144"

11. *Mt. Antero*, 1990
 Sawatch Range
 San Isabel National Forest, Colorado
 368 degree panoramic photograph
 24" x 96"

12. *Mt. Yale*, 1988
 Sawatch Range
 Collegiate Peaks Wilderness, Colorado
 370 degree panoramic photograph
 24" x 96"

13. *Windom Peak*, 1989
 Needle Mountains, San Juan Range
 Weminuche Wilderness, Colorado
 378 degree panoramic photograph
 30" x 144"
 Collection of The Albuquerque Museum

14. *Mt. of the Holy Cross*, 1988
 Sawatch Range
 Collegiate Peaks Wilderness, Colorado
 361 degree panoramic photograph
 16" x 70"

15. *China Bowl Ridge*, 1987
 White River National Forest, Colorado
 376 degree panoramic photograph
 16" x 70"

16. *Blanca Peak*, 1990
 Sangre de Cristo Range
 Sierra Blanca National Forest, Colorado
 388 degree panoramic photograph
 16" x 70"

17. *Handies Peak*, 1987
 San Juan Range
 Gunnison National Forest, Colorado
 372 degree panoramic photograph
 24" x 96"

18. *Uncompahgre Peak*, 1993
 San Juan Range
 Big Blue Wilderness, Colorado
 364 degree panoramic photograph
 24" x 96"

19. *Mt. Sneffels*, 1986
 San Juan Range
 Mt. Sneffels Wilderness, Colorado
 384 degree panoramic photograph
 24" x 96"

20. *Mills Lake*, 1988
 Front Range
 Rocky Mountain National Park, Colorado
 401 degree panoramic photograph
 24" x 96"

21. *Hagues Peak*, 1994
Mummy Range
Rocky Mountain National Park, Colorado
379 degree panoramic photograph
24" x 96"

22. *Grays Peak*, 1989
Mosquito Range
Arapaho National Forest, Colorado
384 degree panoramic photograph
24" x 96"

23. *Pyramid Peak*, 1989
Elk Range
Maroon Bells-Snowmass Wilderness, Colorado
381 degree panoramic photograph
24" x 96"

24. *Medicine Bow Peak*, 1994
Snowy Range
Medicine Bow National Forest, Wyoming
369 degree panoramic photograph
16" x 70"

25. *Tetons*, 1992
Teton Range
Grand Teton National Park, Wyoming
362 degree panoramic photograph
24" x 96"

26. *Cirque of the Towers*, 1990
Wind River Range
Bridger Wilderness, Wyoming
380 degree panoramic photograph
30" x 144"

27. *Green River Lakes*, 1994
Wind River Range
Bridger Wilderness, Wyoming
383 degree panoramic photograph
24" x 96"

28. *Titcomb Basin*, 1994
Wind River Range
Bridger Wilderness, Wyoming
374 degree panoramic photograph
24" x 96"

29. *Fremont Peak*, 1994
Wind River Range
Bridger Wilderness, Wyoming
380 degree panoramic photograph
30" x 144"

30. *Kings Peak*, 1994
Uinta Mountains
High Uinta Wilderness, Utah
371 degree panoramic photograph
16" x 70"

31. *Valley Below Kings Peak*, 1993
Uinta Mountains
High Uinta Wilderness, Utah
362 degree panoramic photograph
16" x 70"

32. *Cloud Peak Ridge*, 1997
Big Horn Range
Cloud Peak Wilderness, Wyoming
390 degree panoramic photograph
16" x 70"

33. *Eagle Peak Ridge*, 1997
Absaroka Range
Washakie Wilderness, Wyoming
373 degree panoramic photograph
16" x 70"

34. *Mt. Lockhart*, 1997
Absaroka Range
Absaroka Beartooth Wilderness, Montana
375 degree panoramic photograph
16" x 70"

35. *Spanish Peaks*, 1996
Madison Range
Lee Metcalf Wilderness, Montana
382 degree panoramic photograph
16" x 70"

36. *Ice Lake*, 1996
Wallowa Mountains
Wallowa Wilderness, Oregon
362 degree panoramic photograph
24" x 96"

37. *Matterhorn Peak*, 1996
Wallowa Mountains
Wallowa Wilderness, Oregon
390 degree panoramic photograph
24" x 96"

38. *Borah Peak Ridge*, 1992
Lost River Range
Challis National Forest, Idaho
366 degree panoramic photograph
24" x 96"

39. *Ward Peak*, 1996
Bitterroot Range
Lolo & St. Joe National Forests, Idaho
382 degree panoramic photograph
16" x 70"

40. *Sawtooth Lake*, 1996
Sawtooth Range
Sawtooth Wilderness, Idaho
397 degree panoramic photograph
16" x 70"

41. *Trapper Peak*, 1996
Bitterroot Mountains
Selway-Bitterroot Wilderness, Montana
361 degree panoramic photograph
24" x 96"

42. *Scapegoat Wilderness*, 1995
Flathead Range
Scapegoat Wilderness, Montana
355 degree panoramic photograph
24" x 96"

43. *Mt. Oberlin*, 1992
Livingston Range
Glacier National Park, Montana
381 degree panoramic photograph
24" x 96"

44. *Rocky Mountain*, 1995
Flathead Range
Bob Marshall Wilderness, Montana
364 degree panoramic photograph
24" x 96"

GUS FOSTER
Born 1940, Wausau, Wisconsin

Selected Exhibitions

1978 *Artwords and Bookworks*, Los Angeles Institute of Contemporary Art, CA

1979 *Cooper, Foster, Hall*, Maggie Kress Gallery, Taos, NM
 New Mexico Photographers, Santa Fe Festival of the Arts, NM

1981 *ARTlines: The First Eighteen Months*, Stables Art Center, Taos, NM
 Group Exhibition, Taylor Gallery, Taos, NM

1982 *Santa Fe Festival of the Arts*, NM
 Panoramic Photographs by Gus Foster, L.A. Louver Gallery, Venice, CA
 Panoramic Photographs by Gus Foster, Marian Goodman Gallery, New York

1983 *Around New Mexico*, DVS/Photographs, Taos, NM
 Erotic Art, Advanced Art Gallery, Rinconada, NM
 Six Seconds Real Time, Advanced Art Gallery, Rinconada, NM
 Current Images, Unicorn Gallery, Aspen, CO

1984 *Christmas in Taos*, DVS/Photographs, Taos, NM
 Gus Foster Panoramic Photographs, University of Michigan Art Museum, Ann Arbor
 Panoramic Photographs by Gus Foster, Multiples/Goodman Gallery, New York
 Photographs in Color, DVS/Photographs, Taos, NM
 Architecture of the Southwest, Stables Art Center, Taos, NM
 The Animal Kingdom, Stables Art Center, Taos, NM

1985 *Art in Embassies*, United States Department of State, Washington, D.C.
 Photography from Northern New Mexico, Mission Gallery, Taos, NM
 The Art Makers, Conlon Grenfell Gallery, San Diego, CA
 On the Wall/Off the Wall, Center for Contemporary Art, Santa Fe, NM
 Landscapes of the Southwest, Stables Art Center, Taos, NM
 Embellished Calendars: An Illustrated History, Cooper Hewitt Museum, New York

1986 *Road Show* (with R. Doen Tobey), San Juan College, Farmington, NM
 Photography from Northern New Mexico, Mission Gallery, Taos, NM
 Statements 86, Fine Arts Gallery, NM State Fairgrounds, Albuquerque
 Panoramic Photographs by Gus Foster, Bergstrom Mahler Museum, Neenah, WI

 Panoramic Photographs by Gus Foster, Leigh Yawkey Woodson Museum, Wausau, WI
 The Pueblos of New Mexico, Stables Art Center, Taos, NM
 The New West, Colorado Springs Art Center, CO

1987 *Food for Thought*, Stables Art Center, Taos, NM
 Earth Eyes/Sky Eyes, Two Photographers: Chappell, Foster, Wohlert Gallery/Nob Hill Cafe, Albuquerque, NM
 Gus Foster: Panoramic Photographs, Lansing Community College, MI
 Artists of Taos 1987, Stables Art Center, Taos, NM
 Skyborn: Aerial Photography, North Dakota Museum of Art, Grand Forks
 Visions, Fine Arts Gallery, NM State Fair Grounds, Albuquerque
 Poetics of Space, New Mexico Museum of Fine Arts, Santa Fe

1988 *Vistas Buenas: Panoramas of Taos County*, Centinel Bank, Taos, NM
 Photo Panoramas, Southern Alleghenies Museum of Art, Loretto, PA
 Time Photographs, Jones Troyer Fitzpatrick Gallery, Washington, D.C.
 Artists of Taos 1988, Stables Art Center, Taos, NM
 Panoramic Photographs by Gus Foster, Kirby Arts Center, Lawrenceville, NJ
 Time Photographs: Central Avenue, Hoshour Gallery, Albuquerque, NM
 New Mexico Wilderness, Focus Series, The Albuquerque Museum, NM
 Visions, Fine Arts Gallery, NM State Fair Grounds, Albuquerque

1989 *Contemporary Photography in New Mexico*, Stables Art Center, Taos, NM
 1989 Invitational, Roswell Museum and Art Center, NM
 Gus Foster Panoramic Photographs, Cirrus Gallery, Los Angeles, CA
 American Hieroglyphics, Stewarts Fine Art Gallery, Taos, NM
 150th Anniversary of Photography, Latvian Photo Art Society, Riga, Latvia, U.S.S.R.
 Time Photographs: 1989 World Alpine Championships, Village Hall, Beaver Creek, CO
 Rendezvous: Bell, Cooper, Foster, West, Broschofsky Galleries, Ketchum, ID
 High Country, New Mexico Museum of Natural History, Albuquerque

1990 *Corporate Art Wisconsin,* Wisconsin Manufacturers & Commerce, Madison
 Night Moves, Millicent Rogers Museum, Taos, NM
 Panoramic Photographs by Gus Foster, The Albuquerque Museum, NM
 Center for Contemporary Arts Invitational, CCA, Santa Fe, NM
 Taos Up Close, Mission Gallery, Taos, NM
 Gus Foster Panoramic Photographs, The New Gallery, Houston, TX

1991 *21 Photographers from New Mexico,* Visions Gallery, San Francisco, CA
 Gus Foster Panoramic Photographs, Thomson Gallery, Minneapolis, MN
 Gus Foster Panoramic Photographs, CAFE Gallery, Albuquerque, NM
 Contemporary Photographers, Ginny Williams Gallery, Denver, CO
 Aspects of Landscape, Nutralite Products, Buena Park, CA

1992 *Gus Foster USA 360,* European Center for American Photography,
 Gallery Mlada Fronta, Prague, Czechoslovakia
 Christmas at Taos Pueblo, The Taos Inn, NM
 Tokaido Road: Panoramic Photographs, CAFE Gallery, Albuquerque, NM
 Tokaido Road: Panoramic Photographs, Harwood Foundation Museum,
 Taos, NM
 Landscapes of Northern New Mexico, The Taos Inn, NM
 Speaking with the Ancestors, Stables Art Center, Taos, NM
 Between Home and Heaven, National Museum of American Art,
 Washington, D.C.
 The New Romantics, Jones Troyer Fitzpatrick Gallery, Washington, D.C.

1993 *Contemporary Art Society V,* CAFE Gallery, Albuquerque, NM
 Views of Kyoto, Cirrus Gallery, Los Angeles, CA
 The Tokaido Road, Doizaki Gallery, Japanese American Cultural Center,
 Los Angeles, CA
 Gus Foster Panoramic Photographs, Thomson Gallery, Minneapolis, MN
 Gus Foster/Panoramic Photographs, The Minneapolis Institute of Arts, MN
 Above New Mexico Skies, Governor's Gallery, State Capitol, Santa Fe, NM

1994 *Panoramic Photographs,* Trading Post Cafe, Taos, NM
 The Tokaido Road: Panoramic Photographs of the Fifty Three Stations, Sasakawa
 Peace Foundation USA, Washington, D.C.
 Plains, Jones Troyer Fitzpatrick Gallery, Washington, D.C.
 Time, Stables Art Center, Taos, NM
 Quiet Skies, Bareiss Contemporary Exhibitions, Taos, NM

1995 *Wilderness Landscapes,* Nicholas/Alexander Gallery, New York
 New Work, New Directions Gallery, Taos, NM

1996 *Plain Pictures: Images of the American Prairie,* University of Iowa
 Museum of Art, Iowa City
 Taos Invites Taos, Civic Plaza, Taos, NM
 The Real West, Denver Art Museum, CO
 Eye of the Camera, 3M, St. Paul, MN
 New Mexico Landscape, Taos Inn Invitational, NM

1997 *Taos Invites Taos,* Civic Plaza, Taos, NM

1998 *Land and Water: The Artists' Point of View,* Colorado Springs Fine Arts
 Center, CO
 Tokaido Road: Gus Foster and Ando Hiroshige, The Minneapolis Institute
 of Arts, MN
 New Works by Contemporary Artists, Gerald Peters Gallery, Santa Fe, NM
 Meet the Artist: Taos Inn Invitational, NM

1999 *The American Rockies: Photographs by Gus Foster,* The Albuquerque
 Museum, NM

Selected Public Collections

The Albuquerque Museum, NM
The Art Institute of Chicago, IL
Center for Contemporary Arts, Santa Fe, NM
Colorado Historical Society, Denver, CO
Cooper-Hewitt, National Museum of Design, Smithsonian Institution, New York, NY
Davison Art Center, Wesleyan University, Middletown, CT
Denver Art Museum, CO
European Center for American Photography, Prague, Czech Republic
The Harwood Foundation of the University of New Mexico, Taos, NM
Kirby Arts Center, Lawrenceville, NJ
Latvian Photo Art Society, Riga, Latvia
Los Angeles Institute of Contemporary Art, CA
Millicent Rogers Museum of Northern New Mexico, Taos, NM
The Minneapolis Institute of Arts, MN
Museum of Decorative Arts, Prague, Czech Republic
Museum of New Mexico, Museum of Fine Arts, Santa Fe, NM
National Museum of American Art, Washington, D.C.
Ohio Wesleyan University Museum, Delaware, OH
San Juan College, Farmington, NM
State of New Mexico, Capitol Arts Foundation, Capitol Collection, Santa Fe, NM
Taos Public Library, NM
The University of Michigan Museum of Art, Ann Arbor, MI
Yale University Art Gallery, New Haven, CT

1975 *Favors*, Sure Co., Venice, CA

1976 *Time Switch*, Orr/Foster, Venice, CA

1976 *American Bicentennial Calendar*, Sure Co., Venice, CA

1976 *Roger Aplon: Stiletto*, Dryad Press, San Francisco, CA

1978 Southwest Art, Vol. 7, No. 1

1978 Picture Paper, Vol. 1, No. 4. Santa Fe, NM

1980 enclitic, University of Minnesota, Vol. 4, No. 1, St. Paul, MN

1980 ARTlines, Vol. 1, No. 1, Taos, NM

1981 *Larry Bell: New Work*, The Hudson River Museum, Yonkers, NY

1981 ARTlines, Vol. 2, No. 2, Taos, NM

1982 ARTlines, Vol. 3, No. 3, Taos, NM

1983 *Roger Aplon: By Dawn's Early Light at 120 MPH*, Dryad Press, San Francisco, CA

1983 ARTlines, Vol. 4, No. 8, Taos, NM

1985 *American Panorama 1985*, Webb Design Studio, Taos, NM

1985 ARTlines, Vol. 6, No. 6, Taos, NM

1985 Photo Design Magazine, October, Minneapolis, MN

1986 *American Panorama 1986*, Webb Design Studio, Taos, NM

1987 ARTlines, Winter, 1986/87, Taos, NM

1987 *Artists of Venice*, Magazine Main, March, 1987, Venice, CA

1987 *Artists of Taos*, New Mexico Magazine, Vol. 65, No. 5, Santa Fe, NM

1988 *Panorama Suggests Endless Possibilities*, Albuquerque Journal, 1/10/88, Albuquerque, NM

1988 *Artists of Taos 1988*, Art and Antiques, May, 1988, New York, NY

1988 Hall, Edward T. *Gus Foster: Clocking in with Einstein*, ARTSPACE: Southwestern Contemporary Arts, Quarterly, Vol. 12, No. 4, Albuquerque, NM

1989 Clark, William. *Photographer Shoots for the Whole Picture: The Panoramic Images of Gus Foster*, New Mexico Magazine, Vol. 67, No. 5

1989 *1989 Invitational Exhibition*, Roswell Museum and Art Center, Roswell, NM (catalog)

1989 *Behold! Work of Taos Photographers*, Taos Magazine, Vol. VI, No. 7, Taos, NM

1989 Kerig, Bill. *Ski Show Premieres Off Broadway*, Vail Magazine, Winter, Vail, CO

1989 Kjessel, Robert. *Han Fryser Tiden I Sex Sekunder*, Skistar, Angang 10/89, Stockholm, Sweden

1991 *Between Home and Heaven, Contemporary American Landscape Photography Postcards*, National Museum of American Art, Washington, D.C.

1991 Onoki, Yoshinori. *Photographs on the Tokaido Road*, Asahi Shimbun, AERA, 3 December 91, Tokyo, Japan

1992 Parks, Steve. *Gus Foster: Master of the Big Picture*, SouthWest Profile, Vol. 15, No. 1, Taos, NM

1992 *Between Home and Heaven; Contemporary American Landscape Photography*, National Museum of American Art, Smithsonian Institution, Washington, D.C. (catalog)

1992 Ensor, Deborah. *Panoramic Photographer Takes to the Road*, Taos News, 4/30, Taos, NM

1992 Morris, Sawnie. *Alchemy and Infinity*, Taos Magazine, Vol. 19, No. 3, Taos, NM

1992 *The Tokaido Road: Gus Foster*, THE Magazine, Vol. 1, No. 1, Santa Fe, NM

1992 Hart, Russell. *Panoramic Photography*, Outdoor and Travel Photography, Fall, 1992, New York, NY

1992 Eauclaire, Sally. *Gus Foster: A View from the Top*, Southwest Art, Vol. 22, No. 6, November, Houston, TX

1993 *Seeing in All Directions at Once Through the Mind's Eye*, Arts, Vol. 16, No. 4, Minneapolis, MN

1993 Hartwell, Carrol T. *Gus Foster/Panoramic Photographs*, The Minneapolis Institute of Arts, Minneapolis, MN (catalog)

1993 Nagano, Taemi. *American Photographer Traces Historic Path of Tokaido Road*, The Rafu, No. 27021, 6/30/93, Los Angeles, CA

1994 *Gus Foster: The Tokaido Road Panoramic Photography*, Sasakawa Peace Foundation USA, Washington, D.C. (catalog)

1995 *The Summit 40th Anniversary Poster: Cirque of the Towers*, Summit Magazine, Vol. 41, No. 3, Hood River, OR

1996 Kinsey, Joni L. *Plain Pictures: Images of the American Prairie*, University of Iowa, Iowa City, IA (catalog)

1998 Turner, David. *Land and Water: The Artists' Point of View*, Colorado Springs Fine Arts Center, CO (catalog)

1998 Badash, Roger. *Taking It All In*, Backpacker, Vol. 26, Issue 173, No. 9, December, Emmaus, PA

1999 *The American Rockies: Photographs by Gus Foster*, The Albuquerque Museum, NM, Essays by James Enyeart, Alan Wallach, Roger Badash, Gus Foster (catalog)

Selected Publications

The Albuquerque Museum is a Division of the Department of Cultural & Recreational Services of the City of Albuquerque.

Staff

Tom Antreasian, *Graphic Artist*
Genaro Apodaca, *Maintenance Supervisor*
Anthony Aragon, *Carpenter*
Linda P. Armenta, *Accountant*
Andrew Cecil, *Preparator*
Philippa Falkner, *Administrative Secretary*
Lester Garcia, *Custodian*
Rose Garcia, *Administrative Support Clerk*
Ramona Garcia-Lovato, *Administrative Aide*
Andrea Gillespie, *Assistant Curator of History*
John Grassham, *Curator of History*
Louise Grindstaff, *Administrative Assistant*
Glen Gunderson, *Carpenter*
Eric Hall, *Preparator*
Ellen Landis, *Curator of Art*
Tom Lark, *Curator of Collections*
Jesus Chuy Martinez, *Program Specialist 4*
Pat Maycumber, *Administrative Support Clerk*
Mark Montano, *General Service Worker*
James Moore, *Director*
Marilee Schmit Nason, *Registrar*
Tom O'Laughlin, *Administrative Manager*

Mo Palmer, *Photoarchivist*
Joey Sanchez, *General Service Worker*
Irene Sanchez-Iverson, *Administrative Aide*
Theresa Sedillo, *Administrative Aide*
Chris Steiner, *Curator of Education*
Anthony Vargas, *Lead Custodian*
Bob Woltman, *Curator of Exhibits*

City Administration

The Honorable Jim Baca, *Mayor*
Lawrence Rael, *Chief Administrative Officer*
Theresa Trujeque, *Deputy Chief Administrative Officer*
Connie Beimer, *Director, Cultural & Recreational Services Department*

City Councilors

Vincent E. Griego, *President, District 2*
Adele Baca-Hundley, *Vice President, District 3*
Ruth M. Adams, *District 6*
Alan B. Armijo, *District 1*
Michael Brasher, *District 9*
Sam Bregman, *District 4*
E. Tim Cummins, *District 8*
Tim Kline, *District 5*
Mike McEntee, *District 7*

Design Burrell Brenneman, Webb Design Studio, Taos, NM **Typography** Karen Sanderson, Webb Design Studio, Taos, NM **Editing** Dawn Hall, Albuquerque, NM **Printing** CS Graphics PTE LTD., Singapore